A Practical Art Therapy

Susan I. Buchalter

Jessica Kingsley Publishers
London and Philadelphia

Cover image "The Eye" used with permission. See p.116 for explanation.

First published in the United Kingdom in 2004
by Jessica Kingsley Publishers
116Pentonville Road
London N1 9JB, UK
and
400 Market Street, Suite 400
Philadelphia, PA 19106, USA
www.jkp.com

Copyright © Susan I. Buchalter 2004

Library of Congress Cataloging in Publication Data
Buchalter, Susan I. (Susan Irene), 1955-
 A practical art therapy / Susan I. Buchalter.
 p. cm.
Includes bibliographical references and index.
ISBN 1-84310-769-4 (pbk.)
1. Art therapy. I. Title.
RC489.A7B78 2004
615.8'5156--dc22

2004003712

British Library Cataloguing in Publication Data
A CIP catalogue record for this book is available from the British Library

ISBN-13: 978 1 84310 769 9
ISBN-10: 1 84310 769 4

Printed and Bound in Great Britain by
Athenaeum Press, Gateshead, Tyne and Wear

For my ingenious husband Alan,
a man who inspires creativity and strength.

Contents

Preface

"Two or three projects are all I can think of: help me." This is a quote I've heard quite often from students, beginning art therapists, counselors and social workers who express the desire to be acquainted with a variety of art therapy techniques. The interns I've supervised, as well as my fellow therapists, appear to be amazed at the diversity and creativity of the projects which I present to clients at the short-term psychiatric facility in which I work. I've written this book to fill a gap, to present a variety of standard and original techniques in an easy-to-read format. One should not view this collection simply as a "cookbook" of therapy techniques. Therapy sessions cannot be scripted ahead of time, but a collection of specific approaches can provide the framework for countless therapeutic interventions. Readers should take it as a challenge to add their own personal touches in order to create sessions that are most meaningful for their particular clientele and themselves.

The techniques illustrated are from many sources: my two decades of experience designing original creative activities for clients, art workbooks, articles, lectures, and workshops. Some of the projects presented have been modified and/or changed to suit a variety of clientele.

Introduction

Many of the projects presented in this manual have proved valuable in my work with depressed, borderline, bipolar, schizophrenic, and addicted clients. The therapist needs to determine the nature of the group, and client needs and abilities when choosing a particular activity. Many of the activities can be modified for a variety of populations including children and the elderly. Children enjoy working with a wide variety of media and color. Seniors benefit greatly from creative experiences focusing on family, memories, and work-related experiences. Many of the seniors prefer media that is not messy or complicated to work with, such as markers and colored pencils.

Socialization, expression of feelings, issues, hopes, problems, and conflicts, as well as the enhancement of reasoning and thinking skills are therapeutic goals for all of these groups; therefore, I will not always specify these goals under the heading "Discussion."

Topics are organized according to technique or media. Many techniques allow for the utilization of a variety of materials. The therapist must determine which materials are most suitable for the population he or she is working with.

I use a wide range of projects/techniques in working with clients. This keeps the clients as well as myself motivated, energetic, and involved. Experimentation allows for growth and new insights.

Warm-Ups

Warm-up exercises give clients a chance to become familiar with art therapy and the group experience. They allow group participants to "loosen up" and relate better to one another. The warm-up helps desensitize apprehensive individuals to the art experience because it is often fun and easy; there are few risks involved. This practice helps convey the message that in art therapy "it does not matter how one draws." It is the expression of thoughts and feelings that are important. Quick creative exercises (usually five to ten minutes in length) often prove helpful in facilitating group interaction and growth. It's beneficial to the group process if the warm-up acts as a transition, relating in some way to the group project.

Squiggle Design

Materials:

Drawing paper, markers, crayons, etc.

Procedure:

Ask clients to draw a scribble with their eyes open or closed. Encourage them to have fun with it. Tell them to let their hands move however they want to. Ask them to look at the scribble from all angles. Suggest they look to see if there is any object in it that looks familiar or if they can find any part of it that attracts them. Have them color that part in and give the picture a title.

Discussion/Goals:

Encourage clients to explore how it felt to draw in such a free manner. Ask participants to examine the item or figure found within the scribble. Have them relate the completed picture to their thoughts and feelings.

Draw with Your Less Dominant Hand

Materials:

Drawing paper, markers, crayons, etc.

Procedure:

Clients are asked to draw a picture with their less dominant hand. The picture can be realistic or abstract.

Discussion/Goals:

Many individuals feel less threatened by this drawing experience because they are clearly not expected to create a *perfect* picture. It's obvious to all that they are at a disadvantage. Clients may discuss the ease or difficulty of doing this task, and their feelings about substituting one hand for another. They may relate this activity to adjustments and substitutions they need to make in their lives when they are ill, lose friends, jobs, family members, etc.

Draw with Your Eyes Closed

Materials:

Drawing paper, markers, craypas, crayons

Procedure:

Ask clients to draw a picture in any way they please with their eyes closed.

Discussion/Goals:

Discussion may focus on risk taking and control issues. The theme of perfection (who needs to be perfect and who can allow themselves to be imperfect) often emerges from this warm-up. This experience allows clients to "loosen up" and freely express themselves.

Cloud Drawing

Materials:

Drawing paper, markers, craypas, crayons

Procedure:

Clients are asked to draw a cloud and something underneath it.

Discussion/Goals:

Discussion centers on both the cloud (its shape, size, color, and meaning for the artist), and the person or item under the cloud. Goals include exploration of mood and emotions. The size of the cloud may represent the degree of depression or fear the client is currently feeling, and how overwhelmed he or she is by external forces.

Draw Your Energy

Materials:

Drawing paper, markers, craypas, crayons

Procedure:

Clients are asked to draw their energy in any way they please.

Discussion/Goals:

Discussion focuses on the way in which the energy is represented (e.g. is it tornado-like or very weak, perhaps symbolized by small, gently curving lines?). Clients then discuss how they relate to their sketch, and their energy level is explored. Goals include examining how best to utilize strengths and maintain balance in one's life.

Form and Environment

Materials:

Small magazine photos, glue, scissors, drawing paper, markers, craypas, and crayons

Procedure:

Have a pre-pasted magazine photo glued onto a sheet of white drawing paper. Ask clients to draw an environment around the photo.[1]

Discussion / Goals:

Discussion focuses on the magazine picture and the environment drawn. Goals include focusing and problem solving.

Draw How You are Feeling Right Now

Materials:

Drawing paper, craypas, crayons, markers

Procedure:

Ask clients to draw their feelings at the present moment.

Discussion / Goals:

Discussion centers on self-awareness and exploration of issues and feelings.

Shape Design

Materials:

Drawing paper, markers, crayons, craypas

Procedure:

Ask group members to draw a design using only circles, squares and triangles.

Discussion / Goals:

Discussion focuses on the manner in which participants create their design and the significance of the artwork. Goals include focusing, problem solving and abstract thinking.

Tiny Design

Materials:

Drawing paper, markers, crayons

Procedure:

Instruct clients to draw a *tiny* figure or design.

Discussion/Goals:

Discussion involves exploring the meaning of the design and thoughts about drawing in such an *odd* manner. Goals include self-expression and increasing flexibility in one's thinking and art.

Drawing in Black

Materials:

White drawing paper, black crayons, markers or pastels

Procedure:

Instruct group members to create a picture (realistic or abstract) using only black marker or crayon.

Discussion/Goals:

Discussion may focus on the design created, and feelings associated with the color black. Goals include self-expression and the exploration of feelings.

Color and Shape

Materials:

Construction paper, scissors, glue

Procedure:

Ask clients to choose a piece of construction paper of the color that most closely represents their feelings at the moment. Then have them choose another sheet of paper the color of which also symbolizes how they feel (this will be the background of the design). Have them cut a shape/s from

the first sheet of paper and ask them to glue it on the second sheet of construction paper.

Discussion/Goals:

Discussion focuses on the colors chosen and the shape/s designed, and how they reflect the clients' moods and feelings. Goals include focusing, problem solving and self-expression.

Picture Completion

Materials:

Drawing paper, markers, craypas, crayons

Procedure:

Group members are asked to find a partner and chat for a minute or two. Then they are instructed to draw a few random lines on their sheet of paper. They are asked to exchange papers with their partner and complete the other person's outline in any way they please.

Discussion/Goals:

Discussion focuses on the manner in which clients completed the picture and their feelings about working with another group member. Goals include problem solving, sharing and socialization.

Straight Line Drawing

Materials:

Drawing paper, markers, colored pencils, crayons, rulers if desired

Procedure:

Ask clients to create a picture using only straight lines.

Discussion/Goals:

Discussion focuses on the artwork and the meaning of the design. Goals include problem solving, abstract thinking and focusing.

Tearing and Sticking[2]

Materials:

Scrap paper, masking tape or glue

Procedure:

Ask clients to tear the paper into shapes, create patterns, decide on a pattern, and then glue pieces together to form an individual design.

Discussion/Goals:

Discussion focuses on the design and its meaning. Goals include focusing, problem solving and abstract thinking.

Household Object Design

Materials:

A variety of small items one might find around the house (e.g. a band aid, tea bag, brillo pad, sponge, penny or nickel, lipstick, stamps)

Procedure:

The group leader places the items in a coffee can and has group members select one object without looking into the can. The participants then place the article on the table and draw something that the object reminds them of, or an experience related to it (e.g. a tea bag might remind someone of a visit with a good friend).

Discussion/Goals:

Discussion focuses on the images represented and the feelings expressed. Goals include problem solving and self-expression.

Dot Picture[3]

Materials:

Markers, crayons, or paint

Procedure:

Ask group members to design a picture using only dots.

Discussion/Goals:

Discussion focuses on the way the design was created and the meaning of the design. Goals include focusing and problem solving.

Notes

1. Clients, especially older clients, are often more willing to draw when something is given to them – perhaps an outline, a border, a shape to fill in and add to or, in this case, a photo glued to paper.
2. From *Creative Arts in Group Work*, by J. Campbell (1993), p.38. Oxford, UK: Winslow Press Ltd.
3. The artwork of Seurat may be explored before this warm-up in order to enhance the creative process.

Murals

Mural making is therapeutic for many reasons. Designing murals increases socialization and cohesiveness within the group. Problem-solving skills are enhanced and self-esteem among group members is raised. Groups may be led in a variety of ways. The mural paper may be placed on the wall, table or floor. Traditionally the paper is taped to a wall and the clients sit in a semicircle facing the paper. They are instructed to (a) choose a theme for the mural and to (b) decide how best to approach designing the picture (e.g. one person drawing at a time, a few members drawing together, etc.). In creating the mural images may be drawn, painted or glued on. Each client gets a chance to draw, for instance, his or her idea, and then speak about his or her drawing. The art is explored both in terms of the individual's self-expression and his or her contribution to the overall picture. Ten to fifteen minutes is frequently spent in making decisions and problem solving.

Certain themes have repeated themselves during these groups. Some ideas include:

- the zoo (draw yourself as an animal in the zoo)
- drawing your monster (this theme facilitates much discussion about fears and problematic areas in one's life)
- illustrating how you feel "right now"
- drawing a fear, fantasy, wish
- drawing where you'd most like to be/least like to be
- illustrating what love, hate, evil and joy means to each person.

High-functioning clients often enjoy working together to create a realistic-looking scene. During this exercise one patient might begin drawing

a house; another might add a garden and a tree to the house; another will draw a back yard, a fence, people, etc. This type of mural instills a sense of pride and cohesiveness among group members. Towards the end of such groups I've often heard comments such as "I can't believe we did such a good job!" and "Let's hang his picture up." Clients frequently mention feeling calm, relaxed and connected to others at the close of mural sessions.

Murals provide patients with a non-threatening method of expressing themselves and socializing with others. Everyone in the group participates in the creation of the mural so there is generally much sharing, discussion and decision making taking place during this creative experience. There are a large variety of mural themes that will enhance the patients' creativity and ability to relate to others in the group.

Cartoon Mural

Materials:

Large sheet of drawing paper, crayons, markers, etc.

Procedure:

Divide a mural sheet into as many boxes as there are group members. Have each person draw whatever they like in one of the boxes. Clients are asked to try and connect the drawings into a narrative.

Discussion/Goals:

Discussion focuses on the meaning of the cartoon and the style in which it was drawn. Goals include communication, group cohesiveness and interaction, expression of issues, organization and structure.

"Color-Feeling" Mural

Materials:

Mural paper, pastels or crayons

Procedure:

Each person selects a crayon to use throughout the activity. Using that one color, clients begin to draw a shape or line, which another member of

the group may add to, continue, complete or change. The only rule is that one person at a time is working. (This rule can be voted on and/or changed by the group.)

Discussion/Goals:

Discussion focuses on the completed image and exploration of how the colors (group members) relate, interact, compete, etc. Goals include problem solving, focusing and socialization.

Mural with Moveable, Cut-out Figures[1]

Materials:

Pastels/crayons, scissors, masking tape, large sheet of mural paper

Procedure:

Ask each group member to draw a figure, cut it out, and tape it (any place they like) on the mural paper.

Discussion/Goals:

Exploration of self-image and group identity.

The therapist may wish to facilitate discussion by suggesting patients observe and explore:

- the size of the figure
- the placement of the figure (e.g. is it on the center of the page, the bottom of the page, in the corner, etc.)
- the sex and the appearance of the figure (does it look like the patient, a friend or maybe a family member?)
- the client's feelings about this self-representation.

Groups I've led including depressed and borderline patients have enjoyed and derived much insight from this project. Many individuals feel a sense of control when they have the opportunity to manipulate themselves (their symbolic figures) on the mural paper environment. When given the option, patients often move their figures to a different position from the original positions they placed them in (e.g. a client will notice after group discussion that he isolated his figure from the others. He may realize that he also isolates himself at home, at work, and with his friends. Sym-

bolically moving himself is a first step toward understanding and changing his behavior and, most important, his attitude in his relationship with others.)

It is noteworthy to mention that defensive clients usually portray themselves as inanimate objects, whereas clients more open to self-examination will draw people.

This project was presented at a hospital in service for staff members. Most of the participating staff depicted themselves as inanimate objects, e.g. a radio (the head psychiatrist), fruit, and a basketball (the recreation therapist).

Group Mural (Long Term)[2]

Materials:

Paint, markers, wood board, pencils

Procedure:

Clients decide on the theme for the mural and they decide how best to approach creating it. On a large wood board the mural is outlined, first in pencil and then in black marker. Clients paint within the marker outline. One, two, or three individuals work on the mural at a time while other group members supervise and give suggestions.

Discussion/Goals:

Discussion focuses on the meaning of the mural and how clients responded to working together. Goals include:

- unifying the group
- encouraging interaction among clients
- reality orientation (becoming concrete, trying to be somewhat realistic in presentation of mural scene)
- ego enhancement (finished product interesting and attractive)
- sense of accomplishment in completing such a complicated project
- the sustaining of interest over a long period of time (may take as long as a few months)
- encouraging decision making and involvement.[2]

Design a Senior Citizen Center

Materials:

Large sheet of mural paper, markers, craypas,[3] masking tape

Procedure:

Clients take turns working together to design their ultimate senior center. They need to make many decisions such as:

- what the facility will look like?

- where will it be located?

- will it be expensive?

- how many rooms will it have?

- will it have a swimming pool, ceramics room, dining room, indoor pool, sauna, etc?

Discussion/Goals:

The group members are asked to create a place where their needs will be fully met. They will focus on cooperation and decision making. This experience allows the client to be in control and explore his or her desires.

Create a Group Meal

Materials:

Mural paper, markers, craypas, etc., masking tape

Procedure:

Clients decide on a favorite meal and draw it together.

Discussion/Goals:

The clients decide which dishes to use for the meal, what type of salad to serve, the main course, side dishes such as corn or peas, dessert and beverage. Goals include socialization, working together (cooperation) and problem solving.

Create a City

Materials:

Mural paper, markers, craypas, masking tape

Procedure:

Clients plan and design a city.

Discussion/Goals:

Clients are asked to think about the city they would most like to live in or to invent their own city. They are asked to decide:

- where it will be located
- what type of people will live there (for example, one group of clients decided only individuals over 60 will live in the city)
- will it be crowded?
- will there be mainly tall buildings or smaller houses?
- what will be the focal points, the weather, etc.

Decision making is focused upon.

Magazine Collage Mural

Materials:

Magazines, mural paper, scissors, glue, masking tape

Procedure:

Individuals cut out pictures from magazines which appeal to them and/or which they can relate to. Each client glues his or her picture to the mural (using glue sticks) until everyone feels the mural is complete.

Discussion/Goals:

Clients discuss their contribution to the mural and the overall appearance of the mural. Everyone is encouraged to ask questions about each other's selected magazine pictures. Group cooperation and cohesiveness is focused upon.

Create a Person

Materials:

Mural paper, markers, craypas, masking tape

Procedure:

Individuals draw a complete person together. Clients take turns drawing the person's head, body, hair, features, etc.

Discussion/Goals:

Clients decide the age, weight, height, sex, culture, religion and financial status of the figure. Group members control whether or not this person has children, is honest, loyal, loving, etc. They decide his or her hobbies, favorite vacation spots, etc. After the figure is completed discussion may focus on whether or not group members relate to this person, and/or does the person remind them of a significant person in their lives. Self-exploration and decision-making skills are explored.

Construction Paper Design

Materials:

Construction paper, scissors, glue, mural paper, masking tape

Procedure:

Clients cut out a variety of shapes from colored construction paper. The shapes might include circles, hearts, squares, squiggles, etc. (If the clients are not able to use scissors the shapes may be cut out for them.) Utilizing glue sticks, they are asked to place the shapes on the mural paper in order to construct a complete design. Group members take turns placing their shapes on the paper one at a time. They may take as many turns as is necessary until everyone is satisfied with the completed project.

Discussion/Goals:

Discussion may focus on the value of working together as a group and decision making. Colors and shapes as reflections of emotions may be explored. Goals include problem solving and socialization.

Design a Group Pizza

Materials:

Triangle shapes, like slices of pizza cut from white drawing paper, markers, craypas, mural paper, masking tape

Procedure:

Each group member receives a triangle "slice of pizza". The clients are instructed to fill in their triangles, creating their favorite type of pizza – sausage, pepperoni, spinach, etc. Then they place (tape) the individual pieces of pizza together so they form a circle (just like a real pizza pie) on a large piece of mural paper.

Discussion/Goals:

Each group member discusses his or her contribution to the pizza pie. The clients then explain ways in which the pizza is reflective of his or her personality, e.g. are you fancy, like pepperoni and sausage, or plain and simple, like a cheese no sauce pie? Self-esteem is focused upon.

Famous Artists Mural[4]

Materials:

Crayons, markers, craypas, colored pencils, a large sheet of brown wrapping paper, tape, art books that focus on well-known groups of artists such as the Impressionists

Procedure:

Make Xerox copies of the drawings of artists such as Monet and Manet: These copies should be outlines, line drawings that are not filled in. The clients are given the copies and the art books and are asked to fill in the outlines of the Xeroxed scenes and shapes with color. They can use the art books for inspiration or guidance. Then they are asked to cut up their pictures so that they are left with the main image of the page, e.g. the person, house, garden. Next participants are asked to glue this image onto a large sheet of mural paper. The last step is for group members to draw a background around their illustrations.

Discussion/Goals:

Goals include socialization, increased communication with peers, focusing and problem solving. Discussion may center on working together, and exploring how the placement of one's artwork on the large sheet of mural paper relates to one's feelings about oneself in the group and home environment.

Joint Scribble[5]

Materials:

Crayons, markers, drawing paper

Procedure:

Each group member creates a scribble with his or her eyes closed. The scribbles are then studied together and explored. Clients decide jointly which one to develop into a finished picture and what it is going to be. Clients work on the picture together.

Discussion/Goals:

Discussion may focus on the individual scribbles and the completed group image. Goals include decision making, cooperation, patterns of leadership, dominance, and task involvement.

Birthday Mural

Materials:

Large sheet of mural paper, markers, crayons

Procedure:

When it is a group member's birthday have the other group members make him or her a mural card. Participants take turns adding a birthday wish, message, and drawing to the mural. Examples of pertinent birthday symbols might be a cake, balloons, presents, flowers, noisemakers, or candles.

Discussion/Goals:

Discussion focuses on the symbols and messages drawn, and the birthday person's feelings about the mural card and support given. Usually the client is surprised and pleased to have the session focus on him or her. It makes that person feel special and honored on his or her special day.[6]

Success Mural

Materials:

Large sheet of white paper, markers, crayons, craypas, masking tape

Procedure:

Ask group members to take turns drawing one or more of their accomplishments on the paper. Ask them to write the year the achievement took place.

Discussion/Goals:

Discussion focuses on each group member's accomplishment and the positive feelings it elicited at the time. The meaning of success is explored. Strengths and self-esteem are examined.

Notes

1. From "Mural with moveable cut-out figures," by M. Rosen (1976) in A. Robbins and L.B. Sibley (eds) *Creative Art Therapy*. New York: Brunner/Mazel Publishers.

2. This project is recommended for use with patients who are long-term inpatients and/or clients who will be participating in a day program for an extended period of time.

3. Craypas are a type of oil pastel that can be used like pastels or crayons. The colors can be blended together to create a new color, or a lighter or darker shade of the same color.

4. This project is a variation of one presented to patients at the University Medical Center at Princeton by Jill Gardner MA.

5. From *Clinical Art Therapy*, by H. Landgarten (1981). New York: Brunner/Mazel Publishers.

6. This mural card has many uses and benefits. It may be designed when clients leave/graduate from a day program or when they leave the hospital; it may then be called a good-bye or celebration mural.

CHAPTER 3

Drawing

Spontaneous drawing allows the client to express problems, feelings, fears, wishes and concerns in a non-threatening manner. Unconscious material, which was previously hidden from exploration, is often depicted in many of the drawings. The artwork enables the individual to communicate symbolically as well as verbally. It affords the client a wealth of symbolism and images which he or she may relate to and learn from. Images serve as vehicles, which facilitate communication, growth, and insight.

During my 20 years of experience I have found that the majority of clients prefer working with markers. Markers are bright, easy to manipulate and easy to see. Crayons and craypas are usually offered during art therapy groups but are chosen less frequently. Some individuals view markers as more sophisticated than crayons, which they see as childish.

I lead a spontaneous drawing group once a week at the mental health facility in which I work. In this group participants choose from a variety of materials to work with (pastels, markers, colored pencils, crayons, craypas, and various types of paper). They are given the option of creating whatever they wish or, as a group, developing their own theme and goals. Clients derive much gain from being in charge in this way. Many of the participants are depressed and are not able to make decisions. This group gives them the opportunity to develop decision-making skills (deciding on materials, artwork, goals). The drawing group allows them the opportunity to be in control, and to relate immediate concerns. One client named George labeled this group "The Challenge."

Draw Your Family

Materials:

Paper, markers, craypas

Procedure:

Have clients draw their families doing something.

Discussion/Goals:

Explore who is in the picture, the size of the figures, how they are drawn (e.g. lightly colored in, heavy emphasis on particular individuals). Relate the picture to the client's feelings about his or her family and his or her role in the family. In working with seniors discuss how one's family might have changed over the years and how the client's role in the family has changed.

Draw Your "Ball and Chain"

Materials:

Drawing paper, markers, craypas, etc.

Procedure:

Clients are asked to draw their "ball and chain": What or who is keeping them from feeling happy and fulfilled. What is holding them down in life.

Discussion/Goals:

Clients explore figuratively and literally the meaning of "ball and chain." Then explore obstacles to success and happiness.

Draw a Best Friend

Materials:

Drawing paper, markers, etc.

Procedure:

Clients are asked to draw a best friend (past or present, realistic or abstract).

Discussion/Goals:

Clients are asked to discuss their special friendship. Support systems and the importance of close relationships in one's life are discussed. Maintaining as well as finding new friendships might be explored.

Name Design

Materials:

Drawing paper, markers, crayons, etc.

Procedure:

The client writes his or her name and draws a design or picture around it, or he or she creates a design using the letters of his or her name.

Discussion/Goals:

Exploration of self-esteem is focused upon.

Draw Your Barrier

Materials:

Drawing paper, markers, etc.

Procedure:

Clients are asked to draw their barrier, meaning what is keeping them from achieving happiness, success, self-fulfillment, good mental health, etc.

Discussion/Goals:

Group members explore their barriers. They explore the size of the barrier, the strength of the barrier, when it was first built, how long it has been up, the difficulty or ease to tear it down, what it looks like, what it's made of, how it makes them feel, etc. One client designed a large brick barrier, stating it would never come down. She was afraid that if it came down she would lose control and literally fall apart.

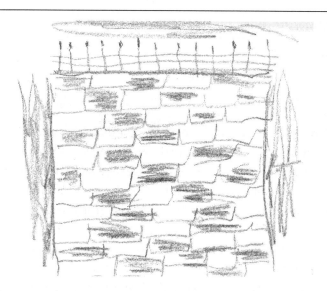

Barrier. A 78-year-old male, suffering from depression, drew this brick wall with "spikes" on the top to keep people away from him. He said he would like to break the barrier down but he doesn't know how to do this. He also said, five minutes later, that he wants to be left alone.

Barrier. Drawn by a 45-year-old male, depressed client who had a stroke seven years previous and walks with a cane. He stated that his barrier is his inability to accept that his disability takes control away from him. He is not able to drive right now and he is not able to accept that his wife is in control. She drives him everywhere and he has to sit in the back seat. His goal is to try to accept being the "helper" instead of the "helpee."

Group Drawing Pass

Materials:

Markers, crayons, drawing paper

Procedure:

Each participant chooses one specific color of marker or crayon. he or she works only with this color during the entire session. One sheet of paper is passed to each individual. A group theme may be decided upon or clients may draw spontaneously. Each person draws on his or her sheet of paper for about two or three minutes and then the group leader says "pass" and each client gives the person to his or her right his or her sheet of paper. Now each individual draws on the paper that was passed to him or her and the drawing continues in this manner. This goes on until each person has a chance to draw on everyone's sheet of paper. The drawing pass is complete when group members receive their original drawing back, complete with each participant's unique sketches and symbols.

Discussion / Goals:

Group members will discuss how they felt about the changes and additions to their original picture. Clients will be encouraged to share their own contributions to each picture. The theme of community, sharing and caring may be explored.

Draw Your Mother

Materials:

Drawing paper, markers, craypas, etc.

Procedure:

Clients are asked to draw their mother in an abstract or realistic manner. They may also choose to draw a memory about their mother, e.g. cooking with her in the kitchen or the smell of bread baking in the oven.

Discussion/Goals:

Group members explore a variety of memories while comparing and contrasting themselves to their mothers. Positive and negative qualities can be explored. Acceptance of oneself is an important goal.

Draw *Yourself* in the Role of Mother/Father

Materials:

Drawing paper, markers, etc.

Procedure:

Clients are asked to design a self-portrait, or draw symbols, which represent their parenting skills.

Discussion/Goals:

Individuals discuss their role in their family and (especially for seniors) how that role has changed over the years. Strengths, skills, and family relationships may be explored.

Draw Your Children/Grandchildren

Materials:

Drawing paper, markers, etc.

Procedure:

Individuals draw their children or grandchildren in an abstract or realistic manner.

Discussion/Goals:

Family relationships and parenting skills may be explored.

Draw Yourself as a Child

Materials:

Drawing paper, markers, crayons, etc.

Procedure:

Clients draw themselves and/or symbols that represent their childhood years.

Discussion/Goals:

The ways in which one's past experiences affect one's present life may be explored.

Spiral Drawing[1]

Materials:

Large sheets of drawing paper, pastels, markers, craypas, crayons

Procedure:

Instruct clients to draw a large spiral. Suggest that they draw significant life events along the spiral path.

Discussion/Goals:

Discussion focuses on "walking the spiral path and telling the story of your life as you stop off at significant points." Exploring the past helps one to understand better present behavior, actions, and attitudes.

Drawing Together

Materials:

Drawing paper, markers, craypas, crayons

Procedure:

Divide group members into pairs and have clients create three drawings together. The first drawing is an abstract, the second is a person, and the third illustration is "the perfect family."

Discussion/Goals:

Discussion focuses on the symbolism depicted in the artwork, each pair's ability to work together, and the ease or difficulty of sharing thoughts and ideas. Goals include socialization, problem solving and exploring relationships.[2]

Draw How You Used To Be/How You Are Now

Materials:

Large sheets of white drawing paper, markers, craypas, etc.

Procedure:

Participants fold a large sheet of white drawing paper in half. On one half of the paper they draw how they used to be (what they were like in the past – any age they choose). On the other half of the paper they draw the way they are now (what they look like, feel like, what their life is like now, etc.).

Discussion/Goals:

Clients discuss what life used to be like for them and what type of person they used to be. They then compare and contrast the past with the present exploring contrasts, changes in their personality, appearance, health, lifestyle, etc. Coping skills and strengths may be focused upon.

Another version of this activity (Landgarten 1981) is to have individuals draw "where I came from, where I am now, and where I am going." Use three sheets of paper and have clients draw their past, present and future on each sheet (or fold one large sheet of paper in thirds).

A Safe Place

Materials:

Drawing paper, markers, etc.

Procedure:

Clients are asked to draw a place where they feel safe and secure, their sanctuary.

Discussion/Goals:

Clients discuss the benefits they derive from their safe place. They are encouraged to use that safe place as a way to build their strength, and to

lessen anxiety by thinking about it when they are tense. Relaxation techniques, which focus on the visual imaging of the sanctuary, may be explored. For example, individuals may be asked to close their eyes, take a few deep breaths and visualize their safe place, focusing on colors, smells, sounds, and positive feelings.

Drawing on Tracing Paper

Materials:

Tracing paper, crayons, craypas, pencils, magazines

Procedure:

Clients are asked to draw an abstract or realistic design on the tracing paper using pencils, crayons and craypas. They may trace a magazine photo if they wish to do so.

Discussion/Goals:

Group members are asked to discuss the meaning of their artwork and to explore feelings about drawing on transparent paper. They might hold their work up to the light and look at the effects. Discussion could then focus on the theme of the meanings of opaque *vs* transparent *vs* translucent. Clients might discuss if they are *transparent* (do they let their feelings show?); *translucent* (do they show their feelings some of the time?) or *opaque* (do they hold everything in – wear a mask most of the time?).

Your Dream/Nightmare: Design a Different Ending

Materials:

Drawing paper, markers, etc.

Procedure:

Clients are asked to draw a dream/nightmare or significant symbols they remember in their dream/nightmare. They are then asked to draw a more desirable ending to the dream.

Discussion/Goals:

Group members may discuss the possible meanings of people and places symbolized in their dreams, and how their dreams relate to their lives. By changing the end of the dream/nightmare the client may gain better control over his or her dreams and emotions, and begin to feel more in control of his or her life.

Draw Yourself Being Assertive

Materials:

Drawing paper, markers, craypas, etc.

Procedure:

Clients draw themselves in a situation in which they acted in an assertive manner and/or they draw how they felt when they acted assertively.

Discussion/Goals:

Discussion focuses on what being assertive means and how it differs from being aggressive or passive. Clients may explore methods in which they can become more assertive and attain more control over their lives.

Draw Your First Bedroom

Materials:

Drawing paper, crayons, etc.

Procedure:

Clients are asked to draw their first bedroom, focusing on the placement of favorite objects and furniture in the room, and their feelings about the room.

Discussion/Goals:

Discussion may focus on what life was like for the individual during the period of time he or she slept in that bedroom.

Anger. Drawn by a 25-year-old woman, suffering from depression and anxiety, who had an abusive childhood and is very angry at her family. No matter how hard she tries, she cannot contain her anger towards them. She tries to contain her anger in the picture with three different boxes, but nothing works. Her anger has generalized to almost everyone she meets and it is ruining her life.

Draw Anger

Materials:

Drawing paper, markers, etc.

Procedure:

Clients are asked to draw anger (what it looks or feels like) using shapes, line and color. In addition they may draw a situation in which they felt angry.

Discussion/Goals:

Discussion may focus on how different individuals express anger and methods of controlling anger. Symptoms, such as anxiety or headaches, which arise when someone is not able to express anger, may be explored.

Draw a Tree

Materials:

Drawing paper, markers, craypas, etc.

Procedure:

Clients are asked to draw a tree in any way they please.

Discussion/Goals:

The tree will be used to represent the self in this activity. After the tree is drawn individuals are asked to see if they can relate to their representation of the tree. The size, shape, strength and placement of the tree on the paper may be explored. Questions such as "How old is the tree?" "Who planted it?" and "How does it withstand rain, wind, snow?" may evoke much conversation.

Draw a House

Materials:

Drawing paper, markers, etc.

Procedure:

Group members are asked to draw a house. It can be the house in which they live now, a house in which they lived in the past or a fantasy house.

Discussion/Goals:

Clients discuss feelings and memories (if applicable) associated with the house. Details, such as the size of the house, the amount of rooms, a favorite and/or least favorite room, the manner in which the house is/was decorated, can be explored. The location of the house and front and rear yards may be focused upon. The house can be considered a representative of the individual, and each individual may explain how his or her house symbolizes him or her.

Draw Goals

Materials:

Drawing paper, markers, etc.

Procedure:

Group members are asked to draw their goals and/or plans for the future.

Discussion/Goals:

Clients are asked to think about short-term and long-term goals. Methods of attaining the goals are explored.

Draw Fear/s

Materials:

Drawing paper, markers, craypas, etc.

Procedure:

Clients are asked to draw something they are afraid of.

Discussion/Goals:

Fears and anxieties are explored. The origins of the fears, reality of the fears, and methods of dealing with the fears are focused upon.

Draw a Fence

Materials:

Drawing paper, markers, etc.

Procedure:

Clients are asked to draw a fence in any way they please.

Discussion/Goals:

The fence (a barrier which separates people or property) may be viewed as a representation of how the client relates to others. Does he or she let people near him or her or does he or she distance himself/herself from people? Does the fence allow the individual to stay in control? The size,

shape, strength, height and design of the fence are explored. The location of the fence, the year the fence was built, what's near the fence, and what's on each side of the fence may be focused upon.

Draw-a-Person Test[3]

Materials:

8x10 inch paper, No. 2 pencils

Procedure:

Have clients draw a person and then ask them to draw another person of the opposite sex. Machover (1940) provides a post-drawing questionnaire and evaluation.

Discussion/Goals:

Discussion includes exploration of self-image and body image.

Draw Yourself Crossing a River

Materials:

Drawing paper, markers, craypas, etc.

Procedure:

Clients are asked to draw themselves crossing a river. They are also asked to draw what is on both sides of the river (the side they are leaving from and the side they are going to).

Discussion/Goals:

The river is symbolic of the client's life. For instance, a turbulent river might indicate anxiety and problems. Individuals are asked to explore the body of water they choose to cross (lake, river, stream, ocean, etc.) and to describe whether or not the water is calm, wavy, deep, cold, dark, etc. The manner in which the client decides to cross the river is then explored. Did he or she use a bridge, boat, stepping stones, an inner tube, or did he or she swim? The way in which the individual crosses the river may be related to the way he or she approaches problems and issues in his or her

life (does he or she swim through life, facing problems head on; does he or she use a bridge to be safe?). Participants explore where they are going in life and where they are coming from when they share what's on either side of the body of water. One woman, for example, drew herself coming from Manhattan and going to the country. She was sharing her retirement concerns. Questions, such as "How do you feel about your present situation, your goals, hopes and dreams?", may be explored.

House-Tree-Person Test[4]

Materials:

8x10 inch paper, No. 2 pencils

Procedure:

Clients are asked to draw a house, a tree, and a person, on individual sheets of paper. Buck (1978) provides a post-drawing questionnaire and evaluation.

Discussion/Goals:

Discussion may focus on explorations of self-image, judgment, maturity, and, as per Buck (1978), "interaction with the environment."

Your First Job

Materials:

Drawing paper, markers, etc.

Procedure:

Clients are asked to draw their first job.

Discussion/Goals:

Group participants are asked to discuss the skills and strengths they needed in order to function effectively at their job. They may be asked to explore their present strengths, and examine how early work experiences affected their goals and dreams.

Problems/Solutions

Materials:

Drawing paper, markers, craypas, etc.

Procedure:

Clients are asked to draw a garbage can, and to think about and/or draw problems they would like to dispose of.

Discussion/Goals:

Discussion may focus on specific problems as well as the exploration of problem-solving skills. This art experience helps individuals get better in touch with issues and helps them explore coping mechanisms. The drawing of the garbage can might represent the intensity of the desire of the individual to rid himself/herself of his or her problems, e.g. the size of the can, placement on the paper, method in which it's drawn (sketched lightly or drawn carefully with a heavy hand). A tiny garbage can might indicate a desire to hold on to issues while a huge can might mean that the issue is overwhelming and/or needs to be disposed of as soon as possible.[5]

Draw the Last Time You Laughed

Materials:

Drawing paper, markers, etc.

Procedure:

Clients are encouraged to draw the last time they laughed heartily. They might be asked to think about where and whom they were with at the time.

Discussion/Goals:

Discussion focuses on the idea of *allowing* oneself to feel joyful. Individuals may explore what specifically makes them laugh and what gives them pleasure.

Draw Your Favorite Vacation

Materials:

Drawing paper, markers, etc.

Procedure:

Clients are asked to draw their favorite vacation. They may draw part of the vacation – for instance, sitting on the beach in Hawaii – or they may be more abstract and draw feelings they had at the time – for example, calm, peaceful, joyful, etc.

Discussion/Goals:

Individuals are asked to describe what specifically gave them pleasure during their vacation. They are encouraged to explore methods in which they may feel similar pleasure, relaxation, peace, etc. in their daily lives.

Draw Your Aches and Pains

Materials:

Drawing paper, markers, craypas, etc.

Procedure:

Clients are asked to draw their aches and pains.

Discussion/Goals:

Discussion focuses on sharing discomfort, releasing sorrow and exploring coping mechanisms. Seniors usually enjoy this art experience because they can relate to each other's ailments; they feel a bond with one another. It gives them permission to complain, to release anger and frustration.

Draw Yourself as an Animal

Materials:

Drawing paper, craypas, markers, etc.

Procedure:

Clients are asked to draw themselves as an animal.

Discussion/Goals:

Discussion may focus on the type of animal drawn and the reasons why the animal was chosen, e.g. someone may draw a house cat because it leads a quiet, comfortable life in a safe environment. Characteristics of the chosen animal may be compared to the artist's personality and lifestyle. Wants and needs may be explored.

Draw Yourself at the Age You Would Most Like To Be

Materials:

Drawing paper, markers, pastels, etc.

Procedure:

Clients are asked to draw themselves at a desired age. They may draw a portrait or something representing their special period of time, e.g. a bottle representing them as a baby, or a notebook representing their elementary school years.

Discussion/Goals:

Discussion might focus on what life was like at the desired age and how it is similar and/or different now. Methods of achieving the positive feelings one felt at the preferred age might be explored. Coping mechanisms are explored.

Palette of Emotions

Materials:

Palettes (the therapist might draw a palette for each group member), markers, pencils, colored pencils

Procedure:

Each client is given a palette already outlined on a piece of white paper. The group participants are asked to fill in the circles of the palette (which are normally filled in with paint) with words, colors, design and pictures to express a variety of emotions.

Discussion/Goals:

Expression of thoughts, issues and feelings are focused upon.

Confusion. A 29-year-old woman who suffers from depression and was recently fired from her job, wrote,"When I am confused I feel like I am going in circles. Now I feel like I am going round and round and round. I can't figure out my problems; I don't know which way to turn."

Draw Confusion

Materials:

Drawing paper, markers, crayons, etc.

Procedure:

Clients are asked to draw confusion, what it looks like or feels like (using line, shape and color), or they may draw a time in their lives when they felt confused.

Discussion/Goals:

Participants discuss what it feels like to be confused. They might explore methods of coping and problem solving, as well as organizational skills.

Draw a Wish

Materials:

Markers, craypas, paper, etc.

Procedure:

Clients are asked to draw a wish.

Discussion/Goals:

Discussion may focus on the individual's wants and needs as well as methods of attaining them.

Draw a Rainbow

Materials:

Drawing paper, crayons, craypas, markers, etc.

Procedure:

Clients are asked to draw a rainbow and to include what is "on the other side of the rainbow."

Discussion/Goals:

Discussion may focus on dreams and wishes, reality *vs* fantasy. The rainbow may be compared to the client's feelings of hope and strength. For example: Is it a large, colorful rainbow or a small, weakly drawn design? Is there a pot of gold at the end of the rainbow or a dark cloud?

Draw Another Group Member

Materials:

Drawing paper, markers, etc.

Procedure:

Clients are asked to draw a group member in any way they wish. They may draw him or her in a realistic or abstract manner, or they may draw something to represent that individual, e.g. a knitting needle and yarn to represent the hobby of a peer.

Discussion/Goals:

Clients discuss their portraits and feelings toward other group members. How they view themselves is compared and contrasted with the way in which others see them. Self-esteem is explored. Socialization and relationships are focused upon.[6]

Draw a Present for Another Group Member

Materials:

Drawing paper, markers, etc.

Procedure:

Clients are asked to draw a present for another group member. The present might be a tangible item, such as a car, or a wish or positive thought, such as good health, more energy, etc.

Discussion/Goals:

Clients discuss the significance of the presents. This will lead to discussion of one's wants, needs, and desires. Methods of dealing with problems and emotional issues may be focused upon.

Draw a Picture Together

Materials:

Drawing paper, markers, craypas, etc.

Procedure:

Clients are asked to find a partner so that the group is divided into pairs. Each pair is asked to create a picture together.

Discussion/Goals:

Participants learn how to cooperate and work together. Decision-making and problem-solving skills are explored. Socialization is a prime focus.

Draw The First Time You Met Your Husband, Girlfriend, etc.

Materials:

Markers, craypas, paper, etc.

Procedure:

Clients are asked to draw the circumstances that led up to meeting their significant other (where they were at the time, what they were doing, e.g. working, riding a bicycle, etc). They are asked to focus on how they felt at the time.

Discussion/Goals:

Communication, the sharing of feelings, and relationship issues are explored.

Senior patients especially enjoy reminiscing about the first meeting with their husbands/wives.

Past Relationships

Materials:

Markers, craypas, paper, etc.

Procedure:

Clients are asked to draw one or more people they have not seen in a long time..

Discussion/Goals:

Discussion focuses on relationship issues. Clients are asked if they would like to reunite, if possible, with this person(s), and what this person(s) means to them.

Draw a Time When You Were Lost or Felt Lost

Materials:

Drawing paper, markers, etc.

Procedure:

Clients are asked to draw a time they felt physically or emotionally lost.

Discussion/Goals:

The expression of feelings, and problem-solving skills are focused upon. Overcoming the barriers we face in life is explored.

Drawing Problems

Materials:

Drawing paper, markers, craypas, etc.

Procedure:

Everyone is instructed to draw a problem. Later the group comes up with solutions for each problem presented.

Discussion/Goals:

Group cohesiveness, decision making and socialization are major group goals.

Draw a Phone Call that You will Never Forget

Materials:

Markers, craypas, drawing paper

Procedure:

Ask clients to draw how they felt when they received a phone call they will never forget. Was it a positive call or something upsetting? Does that phone call still affect them in some way?

Discussion/Goals:

The expression of feelings, and the exploration of the ways in which the past affects our present functioning.

Draw a Move (Recent or in the Past)

Materials:

Drawing paper, markers, etc.

Procedure:

Clients draw a move they have made that affected them in some way (positive or negative).

Discussion / Goals:

Exploring change and how we adapt to change in our lives.

Draw Yourself Driving

Materials:

Drawing paper, markers, craypas.

Procedure:

Clients are asked to draw themselves driving a vehicle (a car, boat, bus, plane, etc.).

Discussion / Goals:

Control issues are explored. Driving a vehicle may be related to how one takes control of one's life (e.g. do you drive fast, slowly, carefully; do you prefer to sit in the passenger seat, etc.).

Draw Change

Materials:

Drawing paper, markers, etc.

Procedure:

Ask clients: "If you could go back in time and change your life what part/parts of it would you change?" Clients express the concept(s) in drawing.

Discussion / Goals:

Individuals may discuss overall satisfaction with their lives, mistakes and achievements. Accepting change in one's life and learning how to cope with change may be explored.

Draw a Favorite Room in Your House

Materials:

Drawing paper, markers, etc.

Procedure:

Ask clients to draw a favorite room in their present home or in any home they have lived in.

Discussion / Goals:

According to some experts the house may be seen as a symbol of the individual and the various rooms can represent different aspects of the personality and/or emotions. Exploration of feelings and emotional well-being may be focused upon. Have participants describe the room they chose:

- Is it large, small, upstairs, downstairs?
- Do they share it?
- Is it pretty, messy, empty, cold, warm?
- Is it a room from their childhood? etc.

Life's Lessons

Materials:

Drawing paper, markers, etc.

Procedure:

Ask clients to draw and share something they have learned over the years that has taught them a valuable lesson.

Discussion/Goals:

Self-esteem is raised as individuals share experiences and give advice to others. The exploration of problem-solving techniques may be focused upon.

Draw Regrets (If Any)

Materials:

Drawing paper, markers, craypas, etc.

Procedure:

Clients are asked to draw regrets about something they have or have not done in the past.

Discussion/Goals:

Participants discuss ways in which the past affects their present lives, feelings, and emotional state. Methods of overcoming life's obstacles are explored.

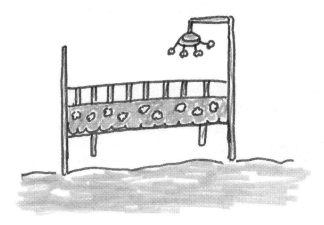

Regrets. Drawn by a 55-year-old depressed woman who regrets never having children. She stated she was too caught up in her career. She spent a long time drawing the crib and remarked that if she had a baby she would buy her the best of everything.

Draw Something Embarrassing that has Happened to You

Materials:

Drawing paper, markers, etc.

Procedure:

Clients are asked to draw an embarrassing incident and/or to draw what being embarrassed feels like, utilizing color and shape.

Discussion/Goals:

There is usually a lot of laughter during this group and so spirits are lifted. Participants learn that it is okay to be infallible and that everyone makes mistakes. Being able to forgive oneself is focused upon.

Draw Your Favorite Possession

Materials:

Drawing paper, markers, etc.

Procedure:

Clients are asked to draw a favorite possession and to discuss the significance of the object.

Discussion/Goals:

Exploration of what is meaningful in life and how to continue to find purpose and meaning is focused upon.

Feeling Trapped

Materials:

Drawing paper, markers, etc.

Procedure:

Ask clients to draw a time in their life when they felt trapped.

Discussion/Goals:

Clients discuss the way/s in which they feel trapped or have felt trapped in the past (trapped in a bad marriage for example). Problem-solving strategies are explored.

Draw Negative Habits

Materials:

Drawing paper, markers, etc.

Procedure:

Clients are asked to draw habits which are harmful to them.

Discussion/Goals:

Individuals explore how to get "unstuck" and how to overcome obstacles in their lives.

Struggles

Materials:

Drawing paper, markers, etc.

Procedure:

Clients draw problems they struggle with on a daily basis.

Discussion/Goals:

Problem-solving techniques and coping skills are explored.

Draw Yourself Being Brave

Materials:

Drawing paper, markers, craypas, etc.

Procedure:

Clients are asked to draw an incident in which they performed a brave act or felt brave.

Discussion/Goals:

Self-esteem issues are explored and methods of dealing with problems are focused upon. This project encourages individuals to focus on their strengths.

Draw Your Favorite Movie or Television Program

Materials:

Drawing paper, markers, etc.

Procedure:

Clients are asked to draw a television program or movie that inspired them, enriched their lives or moved them in some way.

Discussion/Goals:

Participants discuss events in the film/show that they found meaningful. Discussion may focus on how the client relates to the characters, time period, location, and significance of the show. This discussion promotes expression of feelings and issues about one's own life.

Draw Someone who has Deeply Influenced You

Materials:

Drawing paper, markers, etc.

Procedure:

Participants are asked to draw someone who has significantly affected their life in some way.

Discussion/Goals:

Clients discuss a significant individual in their life and the impact that person has had on them. Strengths and coping skills are explored. The effect the past has on the present may help clients gain a better understanding of their behavior and actions.

Draw Your Worries

Materials:

Drawing paper, markers, etc.

Procedure:

Individuals are asked to draw their worries and concerns.

Discussion/Goals:

Clients share their problems; they explore coping techniques.

Draw Advice for the Entire Group or for One Individual Member of the Group

Materials:

Drawing paper, markers, colored pencils

Procedure:

Clients are asked to draw helpful suggestions to an individual or to everyone in the group.

Discussion/Goals:

Drawing advice allows individuals to explore better methods of handling problems. Their self-esteem is raised as they use their wisdom to help others.

Draw Your Family in Order of Importance *When You were a Child*[7]

Materials:

Music (a CD or tape of your choice), drawing paper, craypas, markers, etc.

Procedure:

Clients listen to soothing music and are asked to think back to their childhood years. They are asked to visualize their families and to draw their family members in order of their importance.

Discussion/Goals:

Group members discuss their family and their role in their family unit.
They explore how family relationships have impacted on them. Coping
skills may be explored.

Draw the Best and Worst Thing About Getting Older

Materials:

Drawing paper, markers, etc.

Procedure:

Individuals are asked to draw positives and negatives regarding their age.

Discussion/Goals:

Clients explore the past and the present. Strengths, weaknesses and the
ability to deal with change are explored.

Draw Something/Someone that Makes You Laugh

Materials:

Drawing paper, markers, crayons, etc.

Procedure:

Clients are asked to explore what makes them laugh and what has made
them laugh in the past.

Discussion/Goals:

Participants explore using laughter/humor as a means to relieve stress
and enjoy themselves. Coping skills are focused upon.

Draw Your Feelings about Where You Currently Live

Materials:

Drawing paper, markers, craypas, etc.

Procedure:

Clients are asked to draw attitudes about their present living situation.

Discussion/Goals:

Individuals discuss their degree of satisfaction with their homes and living arrangements, and explore methods of coping as well as methods to change undesirable circumstances.

Self-Awareness

Materials:

Drawing paper, markers, crayons

Procedure:

Instruct clients to draw three things about themselves; have them make two things true and one false. Have the other group members guess which one is false.

Discussion/Goals:

Discussion focuses on self-awareness, socialization and communication skills. Goals include examining and enhancing these skills.

Draw Yourself a Present

Materials:

Drawing paper, markers, etc.

Procedure:

Clients are asked to draw a present for themselves.

Discussion/Goals:

Clients discuss the reasons for giving themselves a particular present. Gifts can be concrete items, such as a bracelet or a car, or positive thoughts, such as happiness and good health. Wants and needs are explored as relationships within the group are strengthened.

Customs

Materials:

Drawing paper, markers, etc.

Procedure:

The therapist and the group members explore various customs people practice throughout the world. Unusual customs may be found on the Web or in various books found in local bookstores and libraries. Clients are then asked to draw the customs with which they are most familiar (holiday, religious, family customs, etc.).

Discussion/Goals:

Discussion of customs leads to exploration of one's family and home life. Discussion may focus on the ways in which customs and culture affect each individual's emotional well-being.

Anxiety Drawing

Materials:

Markers, craypas, drawing paper

Procedure:

Clients are asked to fold their sheet of paper in half. They are asked to draw a time they were anxious on one side of the paper, and to draw how they handled their anxiety on the other side of the paper.

Discussion/Goals:

Discussion focuses on stress reduction and problem-solving skills.

Draw Life "If You were Well"

Materials:

Markers, craypas, drawing paper

Procedure:

Ask clients to discuss their feelings about their life. Then suggest they draw the life they'd like to lead as a "well" person.

Discussion/Goals:

Discussion focuses on goals, plans and hopes for the future. Methods of attaining the health and life clients desire are explored.

Containing One's Anxiety

Materials:

Drawing paper, markers, etc.

Procedure:

Clients are asked to draw their anxiety contained; for instance, in some sort of box or cage.

Discussion/Goals:

Participants explore their anxiety, and methods of stress reduction. Methods of gaining control of one's emotions are focused upon.

Emotions/Conflicts

Materials:

Crayons, markers, paper

Procedure:

Have clients draw two circles. Allow them to choose three colors they like and three colors they dislike. Suggest they fill one circle with the colors they like and one circle with the colors they dislike.

Discussion/Goals:

The clients are encouraged to explore emotions and conflicts in their life by relating the colors to positive and negative feelings.

Anxiety Exploration

Materials:

Drawing paper, markers, craypas, etc.

Procedure:

Clients are asked to draw the ways in which they waste their anxiety. "Wasting anxiety" in this creative experience means expressing anxiety about seemingly trivial things, such as:

- what to wear
- what to eat
- what time to get up in the morning
- whether or not a friend or family member will arrive on time
- the weather
- current events over which no one has control
- petty arguments with peers.

Discussion/Goals:

Tongue-in-cheek at times, discussion focuses on different levels of anxiety and methods of controlling it. Participants are encouraged (methods are explored) to "save" their anxiety for major life events such as illness.

Create a Utopia

Materials:

Paper, markers, craypas, etc.

Procedure:

Discuss the meaning of the word "utopia." Encourage clients to close their eyes, relax, and visualize what their own private paradise would be like. Invite group members to explore this special place; to observe the life-styles, colors, smells, architecture, and weather there. When clients have had sufficient time visualizing this environment ask them to draw a picture illustrating their utopia.

Discussion/Goals:

Individuals are able to express goals, wishes and dreams. Methods of attaining a satisfying life are explored.

Tracing One's Hand

Materials:

Drawing paper, scissors, markers, etc.

Procedure:

Have clients trace their hand and then ask them to draw what they see in the palm of their hand.

Discussion/Goals:

Future goals and desires, and self-awareness, may be explored.

Taking a Risk

Materials:

Drawing paper, craypas, markers, etc.

Procedure:

Discuss what "taking a risk" means. Have clients draw a situation in their life where they have taken a risk.

Discussion/Goals:

Participants may explore how they react to new challenges and changes in their life.

"Spelunking" Cave Exploration[8]

Materials:

Crayons, craypas, markers, drawing paper

Procedure:

Clients are invited to take a metaphorical journey… "Imagine that you are taking a walk in the woods. You come upon an old cave – you 'poke around,' look it over, see what is there. You decide that you will enter and find out what is inside. As you enter the cave, become aware of your surroundings, the temperature, and the cave walls. What do you find there? Take some time and explore the cave as fully as possible. Then, when you

have gone as far as you can go, look it over again. At this point draw a picture of what it is like in your cave. What do you see? Most important, what does it feel like to be inside this cave? Try to convey the total impression – colors, smells, mood, everything – in the drawing."

Discussion/Goals:

The collected drawings of these cave explorations present pictorial representations of various stages of clients' journeys, as well as unique and recurring images and symbols, which may depict personal and transpersonal meanings. The graphics are also viewed for their particular characteristics as well as holistically for overall pattern, and as potential message carriers of where the patient "is at" (general diagnostic impression) and how far he or she has yet to traverse on his or her journey (prognostic impression). It is an exercise that seems to stimulate psychic contents and imagination, yielding forth a wealth of symbol, image and feeling.

Feelings

Materials:

Markers, drawing paper, a coffee can

Procedure:

Each group member writes down a specific emotion/feeling on a small sheet of paper, folds the paper in half, and puts it into one large coffee can. Clients are asked to close their eyes and pick a paper out of the can, read it, and illustrate their response to the emotion written on the paper (e.g. depressed, excited, joyful).

Discussion/Goals:

Goals include expression of emotions, and becoming more aware of attitudes and behavior.

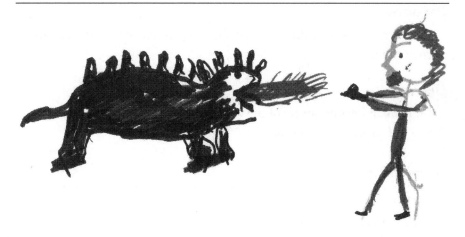

Feelings. A 39-year-old depressed woman drew depression (the dragon) as her monster. When she drew this she was starting to feel better and was able to begin battling it. (She is holding a gun.)

My Needs and Desires

Materials:

Drawing paper, craypas, markers, etc.

Procedure:

Suggest to clients they draw all the things they need on one sheet of paper and all the things they *want* on another sheet of paper.

Discussion/Goals:

Clients may explore a variety of issues including hopes, goals, and wishes. Methods of attaining the desired items may be explored. Their degree of satisfaction with their lives may be explored.

Attitudes toward Others

Materials:

Drawing paper, markers, craypas, etc.

Procedure:

Encourage clients to draw the person they either love, hate, admire or envy the most.

Discussion/Goals:

Individuals become aware of the way they relate to others. Self-awareness and self-esteem are explored.

Hospital Stay

Materials:

Drawing paper, pastels, markers, etc.

Procedure:

Ask clients to draw a synopsis of their hospital stay. Suggest they include people they have met, groups they have attended, and feelings and changes they have experienced.

Discussion/Goals:

The drawing becomes a facilitator in the discussion of discharge plans, goals, and feelings about leaving the hospital program.

Transformation: Working with Partners[9]

Materials:

Drawing paper, markers, etc.

Procedure:

Have another group member draw a more desirable ending to a frightening or unpleasant dream.

Discussion/Goals:

By having a fellow group member change the end of the dream, the client becomes aware of various coping mechanisms, and methods of gaining control of his or her dreams and emotions. He or she may then begin to feel more in control of his or her life.

Past and Present

Materials:

Drawing paper, markers, craypas, etc.

Procedure:

Ask clients to fold their paper in half. On the left-hand side of the paper have them draw an important event that happened to them in the past (e.g. a wedding, promotion, graduation, etc.) and then draw a significant event that happened recently.

Discussion/Goals:

Clients discuss past and present events, and explore the impact these occurrences have had on their lives, their self-esteem, and present relationships.

Draw Your "Ticket" (Symptoms)

Materials:

Drawing paper, markers, craypas, etc.

Procedure:

Encourage individuals to draw their "ticket" (symptoms), which brought them to the hospital, and is keeping them there.

Discussion/Goals:

The artwork may serve to clarify the reasons why the client is in the hospital and the degree of investment he or she has in being ill.

The "ticket" theme facilitates discussion of goals and future plans (are the clients willing to give up their tickets or hold on to them "just in case?") This project is especially useful for "professional patients" (people who put their energy into staying ill). It allows the patient the opportunity to look at the investment he or she has in being and/or staying unhealthy. It gives him or her the chance to explore unhealthy attitudes and coping mechanisms.

Draw Your Family Tree

Materials:

Pastels, markers, drawing paper or cardboard circles the size of dinner plates (found in art supply and party stores)

Procedure:

Suggest to clients that they draw their family tree in any way they please. Tell them they may add as many or as few family members as they please to the tree. When working with clients who need more structure, such as the elderly, I outline a tree and branches on cardboard circles using black marker, and ask the clients to fill in the tree with their relatives.

Discussion/Goals:

Family dynamics are explored. Individuals may explore how their family has impacted on their lives.

Draw Yourself Climbing (a) Mountain/s

Materials:

Drawing paper, markers, craypas, etc.

Procedure:

Instruct the clients to draw themselves climbing (a) mountain/s (the placement of the figure on the mountain/s will be used to represent where the client is on his or her life journey).

Discussion/Goals:

Discussion involves examining the size, shape and placement of the mountain/s and the size and placement of the figure drawn. Sharp mountain peaks, for example, may indicate anger or a fear of getting "stuck" at the top of the mountain. Rounded mountaintops might indicate an easier and safer climb. Clients discuss where they placed themselves on the mountain; are they just beginning the climb? Are they at the top of the mountain, or on their way down? Goals include exploration of goals, self-awareness, and coping skills.

Childhood Exploration

Materials:

Drawing paper, crayons, craypas, etc.

Procedure:

Have clients print their names in a very controlled and slow manner. Ask individuals what this reminds them of (probable answers will include school days, first learning how to write, etc.). Discussion during this exercise leads into the project, which entails asking clients to draw a childhood experience in which they felt very small in comparison to people or things around them. Suggest clients look at their completed work and explore whether or not the picture relates to their present life situation (e.g. are people still overpowering you now?).

Discussion/Goals:

Power issues are discussed; self-image is explored; clients get a better sense of where they were as a child and where they are now. Any changes? Similarities?

Transformation

Materials:

Drawing paper, markers

Procedure:

Ask clients to draw a chape and color it in. Then ask them to transform the shape into an object (e.g. one client drew a triangle and then transformed it into a butterfly. She stated she wanted to be colourful and free like the butterfly).

Discussion/Goals:

Discussion focuses on change and how to adapt to life changes. Clients explore how to use change to improve their lives.

The Maze

Materials:

Drawing paper, markers, etc.

Procedure:

Ask individuals to draw themselves somewhere in a maze. Questions for clients to consider are:

- Where are you in the maze? (In the beginning, middle, or end of the maze?)

- How old were you when you got in the maze?

- If you are in the middle of the maze, when do you think you will be able to find your way out of the maze?

- How does the maze reflect your life?

If some clients, such as the elderly, need more structure you may choose to draw your own maze, Xerox it and allow clients to use that maze to place themselves. Observe the way the client portrays himself/herself in the maze (is the figure large or small, realistic-looking or maybe just a dot?).

Discussion/Goals:

Patients explore problem-solving skills and coping mechanisms. They discuss where they are now in their life and where they would like to be in the future. Methods of overcoming obstacles are focused upon.

Draw a Tornado

Materials:

Drawing paper, pastels, craypas, markers

Procedure:

Discuss what a tornado is and how it affects people and the environment. Ask group members to draw a tornado.

Discussion/Goals:

The tornado drawings are explored; clients may be asked how they relate to their tornado. Questions such as:

- "How strong is the tornado?"
- "Does the tornado cause problems for those around it, and will it cause destruction or harm?"

may be asked. The size, shape and color of the tornado often relates to the client's feelings about himself/herself and how he or she handles stress and anxiety.

Pie Chart

Materials:

Drawing paper, markers, pencils, paper plate to trace a circle, ruler.

Procedure:

Clients trace a circle from the paper plate. Then they use a ruler to divide the circle into four segments. The parts of the circle should be labeled morning, afternoon, evening, and night. Clients should draw what they do during each of these times; they may add a written description if need be.

Discussion/Goals:

Discussion focuses on how clients spend their work and leisure time, and how they feel during different parts of the day, e.g. it is common for depressed individuals to feel poorly in the morning but become brighter and more energized during the evening hours. Goals include problem solving, self-awareness, and exploring leisure activities.

Draw a Situation Depicting Feelings[10]

Materials:

Drawing paper, markers, craypas

Procedure:

Ask clients to draw themselves in a situation that evokes strong feelings. Such feelings might include joy, helplessness and anger.

Discussion / Goals:

Discussion may focus on exploring feelings and attitudes. Coping mechanisms and methods of handling stress are examined.

Notes

1. From *Creative Arts in Group Work*, by J. Campbell (1993), p.81. Oxford, UK: Winslow Press Ltd.

2. If three illustrations are too complicated for certain clients ask them to draw one or two of the pictures.

3. From *Personality Projection in the Drawing of the Human Figure*, by K. Machover (1940). Springfield, IL: Charles C. Thomas Publisher.

4. From *The House-Tree-Person Technique*, by J.N. Buck (1978). Los Angeles, CA: Western Psychological Services.

5. This project is a variation on David Shellie's presentation in A. Robbins and L.B. Sibley (eds) (1976) *Creative Art Therapy*. New York: Brunner/Mazel Publishers.

6. This project would work best in a group where the individuals have been together for a while. In a new group you may pair clients together and allow them to get to know each other for a while before drawing. Do not use this technique if anyone in the group seems suspicious, paranoid or defensive.

7. A variation of an idea by Loris Murdock-Johnson, RN, personal communication.

8. From "The metaphorical journey: Art therapy in symbolic exploration," by K. Rush (1978) in *Art Psychotherapy*, 5.

9. From "Change your dream," by E. Kirson (1976), p.231, in A. Robbins and L.B. Sibley (eds) *Creative Art Therapy*. New York: Brunner/Mazel Publishers.

10. This project is a modified version of Myra Levick's technique as presented in A. Robbins and L.B. Sibley (eds) (1976) *Creative Art Therapy*. New York: Brunner/Mazel Publishers.

CHAPTER 4

Advertising

Advertising design attracted me to the professional world of art, psychology, and eventually art therapy. Art and psychology are highly intermingled in the field of advertising. At the Fashion Institute of Technology, New York, which I attended from 1973 to 1975, I found myself attempting to create advertisements and artwork that relayed a message, caught the eye, had meaning. Over the years I've used my knowledge of advertising illustration to develop therapy projects aimed at eliciting projection of mood, feeling, and issues of importance.

TV storyboards: "Storytelling"

Materials:

TV storyboard pad (these pads are sold at most art supply stores), markers

Procedure:

The pads are divided into about 12 squares, with rectangular boxes placed underneath for writing. Clients are encouraged to draw a story within the squares and write what is occurring in the boxes underneath. Individuals are told they may use all of the boxes or just a few, until their story is told.

Discussion/Goals:

Clients discuss their story and the meaning behind it. The story usually relates to their thoughts, desires, fears and/or fantasies. For example, one individual created a story of a girl being saved from a fire by a handsome fireman. She related this fictional story to her wish for a "Prince Charming," someone who would rescue her from her drab life. This

creative experience helps clients focus, and encourages exploration of feelings and issues.

TV Storyboards: "Commercials"

Materials:

TV storyboard pad, markers, etc.

Procedure:

Clients are asked to design their own commercial. Suggestions may include designing a commercial for products that will help clients live more productive and fulfilling lives.

Discussion/Goals:

Clients are encouraged to explore problems and goals, and methods of attaining those goals.

Logos

Materials:

Drawing paper, paint, ink, markers

Procedure:

The word "logo" (personal symbol) is discussed and examples of famous logos are explored. Discussion focuses on how one's logo or trademark may be used to represent oneself. Clients are then encouraged to design a personal logo.

Discussion/Goals:

Self-image is focused upon. Questions such as: "How do you see yourself, and how do you represent yourself to others?" may be explored.

Advertising: Developing a Product

Materials:

Drawing paper, paint, markers

Procedure:

Encourage clients to develop an advertisement for a product they believe would help themselves and/or others. Ask clients to create the product and present it to the group.

Discussion/Goals:

Problem-solving strategies are examined. Socialization and group interaction are focused upon.

Logo. A client related to this logo because she "loves everyone." She stated she wants people to love her back, but she isn't receiving the attention she desires from people in her life.

Cartooning

Materials:

Drawing paper divided into a number of squares (six squares are optimum), or TV storyboard paper, markers

Procedure:

Clients are encouraged to depict a story through a cartoon. This can be done as a group project (mural-type approach), individual project (within the group), or utilized when working one-to-one with clients (here the

client and therapist create a cartoon together, with the client beginning the cartoon).

Discussion/Goals:

Clients are given a forum to express their issues and concerns; creating a cartoon makes the client feel more relaxed and more willing to express ideas. Serious concerns often materialize in the artwork as a seemingly silly cartoon is explored. Using individual squares to sequence a story helps individuals structure and organize their thoughts and ideas.

Group Television Set Construction[1]

Materials:

Cardboard, construction paper, paint

Procedure:

Encourage group members to design one large television set out of cardboard, and cut out an opening (this opening becomes the television screen). Allow clients to take turns role playing; they could pretend to be the emcee of a game show or the star of their favorite program. Group members are the audience.

Discussion/Goals:

Goals include the facilitation of communication, socialization, and exploration of peer relationships. Clients are given the opportunity to be in the spotlight. Conversation may center on each individual client's reaction to the experience.

Note

1. This project may be geared toward children and adolescents who are usually more willing to "play" in this fashion than adults.

Painting

Paint allows the client a spontaneous, free-flowing method of portraying thoughts and feelings. It is less structured than pencil, crayon or pastel, and gives the client the opportunity to mix colors and to experiment artistically. The client can be messy if he or she chooses to do so; it is acceptable in this creative environment.

In working with many rigid and fearful clients I have found that paint, especially watercolor, gives them permission to move more freely and to take risks with color and design. Taking artistic risks might be the first step toward opening up in other areas of one's life. Many clients find painting with watercolor enjoyable and relaxing, especially when soothing music is played while they are painting.

It is important to keep in mind that paint can be a threatening medium if the need for structure and control is an issue. Some individuals may regress when using this medium.

Mixing Paint

Materials:

Various colors of poster paint, brushes, paper

Procedure:

Individuals are encouraged to experiment, mixing paint to form various shades and colors. Clients are then supported to create a design from the newly mixed colors.

Discussion/Goals:

Problem solving is focused upon. Clients are encouraged to experiment, and to explore how changing and creating a palette of colors may relate to the way they make personal changes and choices in their own lives.

Marble Painting

Materials:

Marbles, paint, watercolor or drawing paper, small bowls, plastic spoons, one or two basins

Procedure:

Clients place one marble at a time in a bowl of paint and then use a spoon to place the marble on the watercolor paper. It is helpful if the paper is placed in a bin so that the client can use his or her hands to move the bin back and forth with the painted marble in it. In this way the paint rubs off the marble onto the paper and a design is created. This may be done with as many marbles (using as many paint colors) as the artist desires. An unusual, Jackson Pollock-like design will be the end result of this type of painting.

Discussion/Goals:

Discussion focuses on the client's reaction to this painting method and his or her thoughts about the completed artwork. Goals include enhancing creativity, abstract thinking, and self-expression.

"Paint and Swirl"

Materials:

"Paint and Swirl" kit also called "Spin Art" (may be ordered from S&S Crafts[1]), tempera paints, paper, crayons

Procedure:

Encourage clients to create spontaneous scribbles, using crayons. Ask them to look for an image or design in their scribbles. Discuss the results. This introduction serves as a warm-up for the "Paint and Swirl" techniques.

Creating "Spin Art" entails giving clients a shiny painting card (copied or taken from the kit); having them dab a variety of paint colors on it; securing the card in the Paint and Swirl machine; and allowing the card to spin in the machine until the paint is spread out and fairly dry. The results often look like Rorschach prints. Clients are encouraged to examine the prints carefully, and add to them using paint or markers in order to design an image. Titling the work is suggested.

Discussion/Goals:

This activity encourages individuals to express their feelings and to become active group members, following directions and problem solving.

Finger Painting to Music[2]

Materials:

Finger paints, paper, a variety of music which elicit different moods (e.g. big band, classical, soft rock, rock and roll, jazz), pencils and writing paper

Procedure:

Play a lively song and have clients begin finger painting. Encourage them to stand up and move to the melody while painting. After the first song is over suggest that clients write their response to the music, and their thoughts about their design. Follow this procedure for three songs and then as a group discuss the artwork, music and written thoughts. (The first song may be lively, the second somber and the third calming.)

Discussion/Goals:

Goals include:

- expression of various emotions
- socialization
- expression of thoughts and concerns
- release of tension and energy.

I have used this technique a number of times with depressed clients. Although reluctant at first, they quickly relax and participate fully in the project. Clients frequently state that they remember childhood situations and school events while painting. Many individuals are surprised at the memories elicited during this group.

This project can be geared toward many populations. Allowing clients to listen to music such as Beethoven and Bach, and having them write their feelings between songs, helps clients view the project as an art experience that adults as well as children may enjoy.

Spontaneous Painting[3]

Materials:

Various paints, brushes, paper

Procedure:

Clients are asked to paint whatever they like. Suggestions may include feelings, dreams, abstract and/or realistic self-portraits, landscapes, friends or family members, and concrete representations such as a flowerpot or bowl of fruit.

I have found that many clients are attracted to acrylics because the paints are easy to use, water-soluble, and squeezed like toothpaste from a tube.

Discussion/Goals:

Paint allows for spontaneous expression of issues and feelings. It encourages clients to "loosen up;" their ideas flow.

Sponge Painting[4]

Materials:

A variety of sponges cut into shapes, poster paint, small bowls, paper

Procedure:

Pour the paint into the bowls. Instruct clients to dip the sponges into the paint and press the sponges on the paper. Encourage them to create a design.

Discussion / Goals:

Discussion focuses on the artwork and its symbolism. Goals include enhancing abstract thinking, creativity, focusing and spontaneity.

Notes

1. S & S Crafts, 15 Mill Street, Colchester CT 06415.

2. Finger painting can cause anxiety and regression so it is important to determine if finger painting is appropriate for the population with whom you are working at the time.

3. Variations of this project include painting to music, the sounds of nature, or instruments that one or more group members might take turns playing (e.g. drums, spoons, tambourines).

4. A variation of this project is to have clients sponge paint to music or sounds (e.g. birds chirping, horns blowing, leaves rustling). They may use colors and shapes that represent the sounds they hear.

CHAPTER 6

Collages

Multimedia collage work allows the added dimension of working with texture and touch. Choices which must be made when selecting materials become an important and therapeutic issue, especially when dealing with depressed clients, who often have difficulty making decisions. Collages can be designed from almost any material. Paper may be cut or torn and glued onto a sheet of construction paper. Paper plates or Styrofoam trays are good bases for collage work. The older client seems to prefer glue sticks rather than glue bottles. They are generally easier to open and easier to manipulate.

Magazine collages provide structure and a relatively non-threatening means of expression. Many individuals I have worked with state feeling "relieved" and "more relaxed than usual" when cutting and pasting meaningful pictures in an organized manner. Elderly clients, who are normally guarded and defensive about drawing, will usually participate fully and share feelings more readily during a collage art experience. In addition to expressing their thoughts and feelings, a major focus of collage work may be assessing the ease or difficulty the client experiences while choosing and manipulating the materials. The way a client works may reflect his or her psychological and physical state.

Design a Face Collage

Materials:

Magazines, scissors, glue, construction paper

Procedure:

Clients cut out facial features from magazines and glue them onto a sheet of paper in order to create a unique face.

Discussion/Goals:

Self-esteem and self-awareness are focused upon. Clients may discuss their satisfaction or dissatisfaction with their appearance and how their appearance affects their mood, attitude and social life.

Mixed Media Collage

Materials:

Tissue paper, construction paper, scissors, glue, etc.

Procedure:

Use a variety of materials including tissue paper, construction paper, Styrofoam, buttons, felt, magazine pictures, glitter and sequins to create a collage which expresses a feeling, such as anger, happiness, or anxiety.

Discussion/Goals:

Explore feelings and concerns. Discuss how the design and materials used represent various emotions.

Tissue Paper Collage[1]

Materials:

Tissue paper, scissors, glue, construction paper

Procedure:

Pieces of tissue paper, in a variety of sizes and shapes, may be provided, or clients may tear and/or cut the paper themselves. The tissue paper pieces are then glued onto a sheet of construction paper. The design may be abstract, or the client may choose to design a more realistic image such as a butterfly or flower.

Discussion/Goals:

Problem solving and decision making are focused upon. Discussion may center on the meaning of colors chosen and the way the client chose to use the materials.

Magazine Collage: Self-Portrait[2]

Materials:

Magazines, scissors, glue, paper

Procedure:

Clients cut or tear pictures from magazines that they identify with or admire. They may want to select pictures which represent their likes, dislikes, surroundings, family and friends. The pictures are then glued onto construction paper. Clients may use markers to add any words or pictures that are unavailable to them in the magazines.

Discussion/Goals:

Exploring self-awareness and self-esteem, and expressing a variety of feelings in a non-threatening manner.

Felt Shapes Collage

Materials:

Felt, scissors, glue, construction paper

Procedure:

Depending on the manual dexterity of the clients, cut, or have clients cut out, shapes from felt squares (e.g. circles, squares, flower-like shapes, silhouettes of people, parts of the body such as the hand or head). Ask the clients to glue them on a sheet of construction paper in order to create a design or image such as a flower in a vase, or a person.

Discussion/Goals:

Discuss the image and how it reflects the client's personality. Problem solving may be explored as clients discuss the ease or difficulty in designing the image.

Catalog Collage (Wants and Needs)

Materials:

Catalogs, construction paper, glue, scissors

Procedure:

A variety of catalogs are presented and clients are asked to cut out pictures of items they would like to have or feel they need to have. The pictures are glued onto construction paper.

Discussion/Goals:

Clients are asked to describe the pictures they chose and to explain the significance of the pictures. Methods of attaining one's wants, needs, and goals are explored.

Memory Collage[3]

Materials:

Magazines, scissors, glue, construction paper

Procedure:

Clients cut and paste magazine photos on a large sheet of drawing or construction paper to represent special occasions, events, and important people in their lives. They may use personal photos and/or memorabilia in addition to the magazine pictures.

Discussion/Goals:

Individuals discuss their past and how their past affects their present actions, feelings and attitudes. The activity enhances one's self-awareness. It is a favorite activity for the older client.

Calming Collage[4]

Materials:

Magazines, glue, scissors

Procedure:

Clients are asked to cut or tear out pictures from magazines that give them a feeling of peacefulness. They are asked to glue the pictures onto construction paper.

Discussion/Goals:

Methods of attaining a peaceful state of mind, and stress reduction techniques are explored.

Figure Collage[5]

Materials:

Template of a person, black markers, scissors, drawing paper, glue, magazines, pencils, oak tag[6] or cardboard, crayons, craypas

Procedure:

The therapist draws the outline of a person (12–18 inches long) on oak tag or thin cardboard and uses it as a template (about three or four templates should be drawn, depending on the size of the group). Each client is given a cardboard template and the therapist encourages the clients to copy the shape of the cardboard figure onto drawing paper. They are then asked to cut out the figure and to use magazine photos, markers, crayons and/or craypas, to fill the figure in. The figure is supposed to represent the client in some way.

Discussion/Goals:

Discussion focuses on the ways in which the figure represents the client. Self-awareness and self-esteem are explored.

Words as Illustrations of Feelings[7]

Materials:

Magazines, scissors, glue, markers, construction paper

Procedure:

The group leader cuts a variety of provocative words from magazines (e.g. angry, exciting, fearless). The clients are then asked to pick one or more of

the words from a pile, and paste them on their paper. Clients may then illustrate the words if they wish and/or arrange them however they please.

Discussion/Goals:

Discussion focuses on the meaning of the words chosen. Goals include exploration of feelings and issues, focusing and problem solving.

Touch Boxes[8]

Materials:

Shoeboxes, feathers, wire, fur, jello, Brillo, foil

Procedure:

Have clients create a mini-environment within a shoebox that describes their personality. Encourage them to explore different textures. Clients may then share their boxes with each other, closing their eyes and touching the contents of the boxes with their fingers.

Discussion/Goals:

Sense perception connected to emotional awareness is explored.

A Collage of Feelings

Materials:

Magazines, construction paper, collage materials such as pom poms, feathers, sequins, pipe cleaners, scissors, glue

Procedure:

Ask clients to create a design that represents one or more feelings or emotions.

Discussion/Goals:

Discussion focuses on the feeling/emotion chosen and the way it is represented in the collage. Goals include problem solving, focusing, and increased self-awareness and self-expression.

A Collage of Another Group Member

Materials:

Magazines, scissors, glue, drawing paper or construction paper

Procedure:

Participants are asked to describe themselves and to talk about their hobbies, interests and goals. They may be divided into groups of two or three, or they make take turns sharing in front of the entire group. Then they are asked to find magazine pictures which remind them of another group member; for instance, pictures of dogs and cats for an animal lover, photos of foreign countries for someone who loves to travel, a beautiful woman to represent an attractive individual. They are instructed to glue these pictures onto a large sheet of drawing or construction paper in any way they wish.

Discussion/Goals:

Clients are encouraged to develop relationships with other group members while learning about their issues and feelings. Identification with fellow group members will help individuals feel less isolated. Communication and socialization skills are focused upon.

Life Experience Collage

Materials:

Magazines, scissors, glue, construction paper

Procedure:

Clients are encouraged to cut or tear pictures that they find meaningful from magazines. They may choose pictures to which they can relate and which symbolize various parts of their life (e.g. a young couple holding hands might represent a special relationship, mountains might represent a favorite vacation). Participants may cut out words, letters and advertisements. The pictures are then glued on a large sheet of white drawing paper in order of importance, or according to time period.

Discussion / Goals:

Discussion focuses on the images chosen, the way the pictures are placed on the paper, the sizes of the pictures and their meanings. Clients explore goals, self-esteem, and thoughts about significant people and events in their life. Their degree of satisfaction with their lives is explored as well as methods to promote positive change.

Inner Body Collage[9]

Materials:

Construction paper, scissors, glue, a variety of textured materials such as cotton, feathers, pom poms, burlap

Procedure:

Encourage clients to close their eyes and relax. Guide a relaxation exercise, having clients tighten and relax the muscles throughout their body (from their head down to their toes). Encourage clients to try to *feel* and visualize their inner body and how it functions (e.g. have them listen to the beating of their heart and then visualize what their heart, lungs, kidneys, etc. look like). When clients have relaxed, opened their eyes, and taken a deep breath, have them create a collage depicting the way their insides felt during the relaxation experience. They may also represent how they think their insides (organs) look.

Discussion / Goals:

Clients should become more familiar with bodily processes, inner as well as outer, and explore how inner body feelings reflect feelings about themselves and their self-awareness.

Self-Representative Box Collage

Materials:

A small cardboard box (many art supply stores and art catalogs sell group packs of boxes that can be easily put together), magazines, scissors, glue, Mod Podge (a type of glue that protects and adds shine to the pictures),[10] clay

Procedure:

Ask clients to choose pictures from magazines that represent them in some way (e.g. their likes, hobbies, favorite foods, etc.) Have them glue the pictures so that they decorate and cover the box.

Discussion/Goals:

Discussion centers on how the pictures represent the group participants. Goals include self-awareness, focusing and expression of issues and feelings.

Self-Awareness Collage

Materials:

Magazines, markers, scissors, glue, paper

Procedure:

Ask clients to create two collages: One depicting their genuine self (a realistic examination of how they view themselves now), and the other representing their fantasy self (how they'd like to be – their ideal self).

Discussion/Goals:

Clients are encouraged to explore self-image, goals, discrepancies (if any) between their real self and fantasy self, and methods of achieving healthier integration.

Music-Inspired Collage

Materials:

Music tapes, magazines, mural paper, scissors, glue, masking tape

Procedure:

Play recordings of classical or romantic music (or whatever music is suitable for the population you are working with at the time). Have the clients close their eyes, relax and *feel* the music. Have them imagine that they see the music: the shapes, colors, and movement of the music. Next suggest that they look through the magazines and cut out pictures which relate in some way to the music they just listened to.

Discussion/Goals:

Clients focus on expressing feelings and emotions. They might explore ways in which music and meditation relax them.

Create a Planet

Materials:

Construction paper, markers, glue, scissors, feathers, pipe cleaners, a variety of textured materials

Procedure:

Have clients design their own planet utilizing a variety of collage materials.

Discussion/Goals:

Discussion may focus on the type of planet designed and the materials used. Clients explore the similarities and/or differences between their lives/environment and the world they created. Participants are given the opportunity to control and manipulate their environment, and to explore their feelings and reactions toward their surroundings.

Popsicle Stick Collage

Materials:

Popsicle sticks (plain or colored; they may be found in art supply stores or they may be purchased from many art supply catalogs), glue, construction paper

Procedure:

Clients are given a large handful of sticks and asked to place them on the construction paper in order to create a design (realistic or abstract). The plain Popsicle sticks may be painted if desired.

Discussion/Goals:

Goals include problem solving, focusing and abstract thinking. Discussion may focus on the meaning of the finished artwork and on the placement of the sticks. It is interesting to observe which participants

keep the collage two-dimensional and who begins to build with the sticks creating more of a three-dimensional look. This may reflect a risk-taking personality *vs* a personality that is more subdued, a person with a conservative approach to life.

Notes

1 A variation of this type of collage is to paint Mod Podge (a glue used for collage and wood work) on the construction paper and then place the cut-up tissue paper on top of the construction paper. Next paint the Mod Podge on top of the design that was created. The colors of the tissue paper blend into one another for an interesting effect.

2. Variations of the collage might be a Happiness Collage, Anger Collage or Word Collage (clients cut out words and sentences from the magazines that they find meaningful).

3. A variation of this collage is a Memory Book composed of three or more pages filled with photos from magazines that remind the clients of past experiences, friends and family.

4. A full body relaxation exercise might precede the art experience. The clients may then be asked to design a collage of the serenity they felt during the relaxation exercise.

5. During a recent group session I connected the figures to create a type of mandala. The centre of the circle was the feet, with the figures radiating outward like spokes of a wheel. Clients took pride in the mandala, pointing out their contribution to it frequently. It became a symbol of the therapy group.

6. Oak tag is a thin, bendable cardboard that usually comes in squares of approximately 3'x3'. It is often used to design posters.

7. Another variation of this collage is to have the clients cut out the words from the magazines; they then create a collage from the words chosen.

8. From A. Robbins and L.B. Sibley (eds) (1976) *Creative Art Therapy*. New York: Brunner/Mazel Publishers.

9. This art therapy experience is a modified version of a workshop in which I took part during Pratt's 1981 Creative Arts Therapy Expo.

10. Clients may create small self-representative clay sculptures, and these figures could be placed in the box.

Puppets and Masks

Puppets and masks allow for role play and exploration of thoughts and feelings. Clients are given the opportunity to project emotions, concerns, and ideas through their creations. Play-acting with puppets and masks allows clients to explore inner feelings and outer experiences. It helps them express issues that they might be inhibited to share otherwise.

Masks may be created utilizing paper plates, paper bags, and construction paper. Art catalogs sell the cardboard outlines of masks for very reasonable prices. Cutting and pasting a variety of materials on a circular piece of cardboard or oak tag may form a paper collage mask. Materials – such as magazine pictures, newsprint, felt, sequins – and all types of textures – such as feathers, cotton and burlap – may be utilized.

Mask. Drawn by a bi-polar male client. When he constructed this mask he was hypo-manic, telling jokes (some of which bordered on being inappropriate).

Paper Bag Puppets

Materials:

Paper bags, paint, markers, collage materials such as sequins, feathers, cotton, yarn

Procedure:

Have clients paint or draw a face on the bag. Encourage clients to add hair and adornments.

Discussion/Goals:

Role play with the puppets is encouraged. The focus is on self-awareness and communication of feelings; self-esteem issues may be explored.

Clothespin Puppets

Materials:

Rounded clothespins, glue, pipe cleaners, markers, tissue paper, felt, material, wool

Procedure:

Have participants create a puppet using a clothespin as the body. They may draw a face on the puppet and add hair (wool) and clothes (using felt or material). Arms may be made with pipe cleaners.

Discussion/Goals:

The puppets may be used for role play. Discussion may focus on exploring how the puppet relates to the client and/or his or her friends and family. It is interesting to discuss the type of figure the client chose to create: Is it an adult or a child? A realistic figure or a fantasy character, such as a princess, a Martian, or a monster?

Paper Cup Puppets[1]

Materials:

White paper cups, small Styrofoam balls, scissors, toothpicks, markers, paint, wool, sequins

Procedure:

Place the cup upside down so that the opening of the cup is on the table. Either glue the Styrofoam ball onto the base of the cup or use a toothpick to attach the ball to the cup (the toothpick would go halfway through the ball and then into the cup). Now the body of the puppet is complete. The puppet may be painted and decorations may be added to create a character. Material and/or felt may be used to design clothes. Arms may be added with pipe cleaners; hands may be designed using felt.

Discussion/Goals:

Clients may project their feelings and concerns onto the puppets.

Newspaper Puppets

Materials:

Many newspapers, scissors, glue, collage materials, markers, paint, rubber bands

Procedure:

Take about 12 sheets of newspaper (add more sheets if you want a thicker puppet). Put the sheets one on top of the other. Now roll them up into a cylinder (roll the newspaper horizontally unless you are using the *New York Times* or another broadsheet, when you should roll it vertically. Once the paper is rolled, place a rubber band around the cylinder to keep it together. Take scissors and cut the top part of the cylinder into strips about four inches long, cut many strips. The strips become the hair of the puppet. Bend the strips downward. The area under the strips becomes the face; add features and decorations to the long, narrow body.

Discussion/Goals:

Clients are encouraged to use the puppets as a non-threatening way to express their issues and concerns. Goals include focusing, abstract thinking and problem solving.

Milk Container Puppets

Materials:

Milk containers, construction paper, scissors, glue, felt, yarn, any other collage materials such as sequins, buttons, feathers

Procedure:

Cut the milk containers in half (leaving one end connected). Ask clients to cover the container with construction paper. Encourage clients to cut out and then paste facial features, hair and clothes onto the puppet (using yarn, felt and construction paper). The milk container should be connected on one end so that the upper and lower portions of the container can be opened and closed using one's hand. The carton should open and close like a mouth. Both a one-quart container and a half-gallon container work well.

Discussion/Goals:

Goals include enabling clients to attain a clearer sense of self, and enhancing communication among clients through role play. Clients may be asked to create any type of puppet they please or they may be instructed to create puppets:

- which are similar to themselves
- that remind them of a friend or family member
- that are representative of someone in their life they are having problems dealing with at this time
- which are themselves as children

They may be instructed to speak with the puppet or, through role play, have the puppet share its thoughts and concerns.

Clay Masks

Materials:

Clay, modeling tools, paint (Pour-o-tex or Mod Podge if no kiln is available. Mod Podge is a type of glue finish that dries clear and helps preserve works of art. It is available in art supply stores)

Procedure:

Have clients create a mask out of clay in any way they wish. The masks are usually created as flat surfaces with three-dimensional features. When the mask is dry and hard have clients paint it and, if desired, glue on decorations.

Discussion / Goals:

Discussion often focuses on self-image. Clients may use the masks to share issues and feelings. They may even place the mask over their face, speaking through the mask, to share thoughts and concerns. In this manner issues can be explored in a relatively non-threatening manner.

Milk container puppet. Designed by a teenager dealing with her parents' divorce. Since the mouth of this puppet opens and closes, the client used the puppet to vent her feelings about the divorce, opening and closing the mouth of the puppet rapidly, so that the puppet appeared to chastise both parents.

Papier Mâché Masks

Materials:

Balloons, *papier mâché* paste[2], newspaper, paint, wool, feathers, collage materials

Procedure:

Have clients blow up a balloon, and then cut or tear strips of newspaper, which they dip into *papier mâché* paste. Store-bought paste may be used or the paste may be made by adding flour to water until it has thin glue-like consistency. Instruct clients to place these strips on their balloon (about three-quarters of the way around). Let the balloons dry for 24 to 48 hours. When the ballons are dry, clients will break them with a pin and cut the hardened *papier mâché* until it looks mask-like and covers the face. Clients may decorate the masks with paint, beads, wool, etc. When creating the face, individuals can add the nose, lips, chin, eyebrows, etc., by taking paper towels, soaking them in the *papier mâché* and molding features on the face (in the same way as working with clay). Newspaper dipped in *papier mâché* combined with strips of dry paper towels will facilitate the drying process.

Discussion / Goals:

Discussion may center on the exploration of feelings, and self-image.

Notes

1. Cardboard cones may be used instead of cups. These cones are available in art supply stores. The cardboard roll from toilet tissue is also an excellent base for this type of puppet.

2. Recipe for *papier mâché* paste (from *Family Fun Magazine*, 4/03):

 4 cups of water

 1/2 cup of all-purpose flour

 3 tablespoons of sugar

 Bring two cups of the water to the boil in a saucepan. Combine the flour and two cups of cold water in a bowl. Stir the paste into the pan of boiling water and bring the mixture back to the boil. Remove the pan from the heat and stir in the sugar. Let the mixture cool (it will thicken as it does) and it's ready to use.

CHAPTER 8

Sculpture

Engaging in sculpture design allows clients to see things three-dimensionally. Observing a form in all of its aspects – front, back, sides, top and bottom – encourages individuals to broaden the way they view life; to see situations from more than one vantage point. Abstract thinking is focused upon; this gives the client the ability to explore his or her problems from many perspectives. He/she learns that life has gray areas; everything is not black and white. Sculptures, mobiles and dioramas give the individual the opportunity to mold, shape, build and manipulate his or her environment.

Life Sculpture

Materials:

Clay, plastic carving tools

Procedure:

Create a sculpture that represents various elements of your life, e.g. a man and a woman connected to children to represent family, a car and buildings to represent working in the city. Clients may sculpt as many symbols as they like.

Discussion/Goals:

Clients discuss various aspects of their life and are encouraged to assess their strengths, achievements and goals. When presented to seniors reminiscing becomes an important goal.

Clay Sculpture

Materials:

Clay (clients often enjoy terracotta clay if they don't mind getting their hands dirty, otherwise Model Magic is a popular choice for many individuals), sculpting tools

Procedure:

Participants are asked to sculpt themselves, their family, or a feeling.

Discussion/Goals:

Clients discuss feelings and emotions associated with their sculptures. They examine the size, shape and meaning of their artwork. Family issues and self-esteem may be explored; strengths and needs may be focused upon.

Creation of a Three-Dimensional Scene

Materials:

Cardboard, construction paper, glue, scissors, pencils, markers, crayons

Procedure:

Have clients discuss various environments; for example, their home, a peaceful place, favorite vacation spots, an uncomfortable environment, their ideal environment, and then ask them to create their own special environment using the material provided. Ask participants to design and cut out pictures or models of people, animals, cars, houses, shapes, plants, trees, etc. Individuals are encouraged to paste these items onto a cardboard base to create three-dimensional scenes.

Discussion/Goals:

Goals include creating a greater awareness of the client's position in space and in relation to others. Having the clients create a scene or environment offers them the opportunity of projecting themselves in that space; it gives them the power to control their surroundings in a symbolic way.

Box Sculpture

Materials:

Milk and juice containers, various assorted boxes, scissors, glue, paint, various odds and ends, such as straws and corks

Procedure:

Place the milk and juice containers and assorted boxes in the middle of the table and allow participants to choose whichever boxes they please. Ask the clients to create a three-dimensional design which may be realistic or abstract. The sculpture may be painted if desired.

Discussion / Goals:

Goals include enhancing socialization and decision-making skills, focusing and abstract thinking. By using their inner resources, feelings and ideas, the clients are creating something meaningful to them.

Pariscraft Sculpture

Materials:

Pariscraft[1] (may be purchased at S&S Crafts or in most art supply stores), aluminum foil, paint.

Procedure:

Ask the clients to design a realistic or abstract sculpture, perhaps a person, animal, house or three-dimensional shape. First have participants design the sculpture out of aluminum foil and then have them put Pariscraft over the structure (cut Pariscraft into strips and moisten it). Let the Pariscraft dry and then paint the sculptures.

Discussion / Goals:

Self-awareness is focused upon; clients often become more attuned to their feelings and issues by projecting and role playing with the sculptures.

Snow Sculpture[2]

Materials:

Snow, large modeling tools (wooden utensils may be used to sculpt the snow)

Procedure:

Conduct an art therapy session outdoors and ask clients to decide on a theme for the snow sculpture. Have them decide how to create the sculpture and who should work on each part of it.

Discussion/Goals:

Goals include socialization, abstract thinking, and the expression of thoughts and feelings. The group becomes more cohesive as clients work together and share ideas. Discussion may focus on how it felt to work on the project, and what the finished sculpture means to each person.

Eclectic Group Sculpture

Materials:

Various boxes (all sizes and shapes), cereal boxes, milk cartons, and other items such as the cardboard from paper towel rolls and tissue boxes, paint

Procedure:

Each group member participates in the creation of the sculpture. One group member at a time will pick an item from a large container filled with the boxes and other objects. Each client will place and glue his or her selected box/cardboard item in a position he or she finds pleasing. This will continue until the sculpture is designed and complete. Once finished, group members paint the sculpture. The sculpture may be hand-painted or spray-painted. Silver spray paint creates an exciting effect.

Discussion/Goals:

There is usually a lot of discussion and interaction among group members during this art therapy session. Clients discuss the theme for the sculpture as well as where to place the items used in creating the design. Goals include the enhancement of socialization and decision-making skills,

abstract thinking, and focusing. Participants gain a sense of control as they decide where to place the objects and offer suggestions to peers. The completed sculpture instills a sense of pride in the clients and unifies the group. Group decision making and group dynamics can be observed.

Wire Sculpture

Materials:

Assorted wire including phone wire, which is thin and colorful (this wire can be ordered from many art supply catalogs and can be found in various art supply stores)

Procedure:

Encourage clients to create a figure from the wire. They may make an animal, person, or abstract design.

Discussion/Goals:

Discussion may focus on the ease or difficulty involved in working with the wire, how clients coped with any problems designing their figures, and the meaning behind their work. Goals include abstract thinking, decision making, focusing and the expression of thoughts and feelings.

Wood Sculpture

Materials:

Assorted pieces of wood (large bags of wood pieces may be found in many art supply stores), glue, paint

Procedure:

Clients are asked to choose a variety of wood pieces and glue them together in order to create a sculpture which is meaningful to them. When the sculptures are dry participants may paint them if desired.

Discussion/Goals:

Discussion focuses on symbolism and exploring how each client felt when creating his or her work of art. Goals include problem solving, focusing, and abstract thinking.

Marshmallow Sculpture

Materials:

Large marshmallows and mini-marshmallows, toothpicks or thin pretzels (which can be used instead of toothpicks)

Procedure:

Group members are asked to use the toothpicks (or pretzels) to connect the marshmallows in order to create a three-dimensional design. After group discussion the sculptures may be eaten.[3]

Discussion/Goals:

This is a fun project, which usually sparks lots of laughter and conversation. It is a challenge for participants to create a design that doesn't collapse and is attractive. (Many individuals design a box or a house.) Exploring the meaning of perseverance and how one deals with frustration may be focused upon. Problem-solving strategies may be explored.

Cookie People Sculpture

Materials:

Baker's clay:
 1½ cups hot water
 ¾ cup salt
 4 cups flour
 ½ cup sugar (if you want to enhance the taste)
Aluminum foil, cookie tray, red hots (candy), tiny sugar stars, assorted miniature candies, tube icing

Procedure:

Work with group members to mix up all the ingredients to make the dough. Then ask clients to design a figure out of the dough. When the figures are complete bake them at 325°F until hard. Now clients may decorate the figures.

Discussion / Goals:

Discussion may focus on exploring feelings about the figure and who the figure may represent; for example, someone's friend, mother, or husband. Ask clients what they want to do with their cookies; they have the option of saving the figure, eating it, eating part of it, etc. I have led groups where clients chose to eat just the head of the figure (usually if they disliked the person the figure represents), and I've observed people crushing the figures. In this way participants gain mastery over the person symbolized as a cookie figure; the client decides his or her fate. Goals include self-awareness, projection and expression of feelings, release of tension (by molding, pounding and manipulating the dough).

Notes

1. Pariscraft comes in rolls and when wet it becomes malleable, similar to *papier mâché*.

2. I have created many snow sculptures with clients over the years. Popular themes are snow people, snow families, and abstract structures. Three individuals with whom I worked a few years ago created a torso of a man. The clients who worked on the torso became very involved in the project. One of the participants decided that the figure reminded her of her father and asked other clients to help her add a few touches to make the torso become a person, "to look even more like my father." When this sculpture was completed group members spoke about their feelings toward it. The young woman who thought it looked like her father discussed her feelings about him; she spoke to the sculpture and touched it. She stated, "I am saying things to this snowman I could never say to my real father." Designing this sculpture was therapeutic for this individual because she was able to express anger and fear toward her father – feelings that were previously repressed.

3. It is fascinating to observe who eats their sculpture, who saves it and who knocks it down. Discussion may center on how individuals treat their sculptures.

CHAPTER 9

Clay

Working with clay gives the client the opportunity to "get dirty," to freely express himself/herself. Feelings may be expressed in variety of ways. Individuals may pound, squeeze, and manipulate the clay in order to vent anxiety, anger, and excitement. The client becomes the master of the clay; he or she is in control of it.

Clay work affords the client the opportunity of working three-dimensionally, seeing things from more than one perspective. Utilizing clay allows clients to mold behaviors, attitudes, and self-image. Participants gain insights and develop new methods of coping and problem solving.

Feeling Sculpture

Materials:

Clay, modeling tools, water

Procedure:

Encourage clients to verbally list a variety of feelings/emotions (e.g. excited, sad, anxious). Ask one group member to write the feelings on a blackboard or a large sheet of paper. Instruct clients to choose one of the feelings suggested and sculpt that feeling using the clay.

Discussion/Goals:

Discussion focuses on the feelings sculpted and how each group member relates to his or her artwork. Goals include self-expression and enhancing one's self-awareness.

Possessions

Materials:

Clay, modeling tools

Procedure:

Suggest that clients sculpt three things they have a lot of and three things they don't have enough of. (The amount of items sculpted may be changed according to the functioning level of the group.) Clients are then given the opportunity to share with others and exchange items (e.g. one client may have enough money but not enough love; so the symbolic money could be traded for another client's clay love symbol).

Discussion / Goals:

Discussion may focus on wants and needs. Group members can explore how they negotiate for what they desire in life. Group interaction is emphasized and socialization skills are focused upon.

Sculpt Your "Monster"[1]

Materials:

Clay, modeling tools, water

Procedure:

Suggest to clients that they experiment with the clay, with the feel and touch of it, and then sculpt their "monster." The meaning of "monster" as it pertains to this project may be explored first. Monsters will be different for each participant – one person's monster might be his or her reluctance to seek help when needed; another person's monster might be his or her temper.

Discussion / Goals:

Patients explore problems and self-defeating behaviors. They are given the opportunity to project their fears and frustrations onto their sculptures. Goals include problem solving and gaining greater self-awareness.

Monster sculpture. An elderly depressed client related this monster to her fear of the future. She remarked that the future is her monster.

Family Sculpture[2]

Materials:

Clay, modeling tools

Procedure:

Clients are asked to sculpt family members engaged in an activity.

Discussion/Goals:

Goals include the exploration of family dynamics, and examination of the client's feelings about his or her position in the family.

Create a Figure

Materials:

Plasticine or Model Magic[3], paper, markers

Procedure:

Ask clients to create a figure or form out of plasticine or Model Magic. Encourage group members to examine it from all angles, and then describe how they felt creating it and their reactions to it. Clients may include feelings they experienced while working with the clay; they may

do this by writing their thoughts on paper. Participants may choose to write questions and/or thoughts *to* the form.

Discussion/Goals:

Goals include the expression of thoughts and feelings, focusing and abstract thinking. Discussion may focus on exploring the meaning of the sculptures.

Clay Figures in Mural Environment

Materials:

Mural paper (large sheet of brown or white paper: the paper used for wrapping packages works well and can be found in rolls in many stores), clay, markers

Procedure:

Ask clients to create a clay figure. Have them place the figures on the mural paper (cut a piece large enough so that it covers a good part of the table or floor). Ask the group participants to draw an environment around the figures.

Discussion/Goals:

Discussion focuses on figure placement (is the figure near or apart from the other figures; is it in the center of the paper or in a corner?), the environment drawn, and relationships with friends/family and other group members. Goals include increased socialization and increased self-awareness. During this art experience individuals are given the opportunity to manipulate and control their environment.

Working with clay figures allows the clients the opportunity to move the figures, bend them, re-mold or squash them. There is much ventilation of feeling.

Pinch Pot[4]

Materials:

Clay

Procedure:

Instruct clients to form a clay ball the size of their fist; next have them push their thumb down the center of the ball. Then they pinch their thumb against their fingers while rotating the clay ball. Encourage them to stay centered so that the pot becomes balanced.

Discussion/Goals:

Goals include focusing, and centering. Discussion may include reactions to one's finished product and how each pot reflects the artist's personality. For instance, is the pot balanced and is the designer of that pot balanced? Is the pot lopsided; does that reflect the designer's personality or the way he or she handles problems?

Sculpt Your Stress

Materials:

Clay, modeling tools

Procedure:

Ask clients to sculpt their anxiety/stress.

Discussion/Goals:

Clients sculpt their stress and analyze it (looking at the shape, size, design, etc.). Methods of understanding and managing stress are explored.

Notes

1. Clients usually become very involved in this project. The idea of a monster seems to appeal to depressed and borderline clients. The sculptures are usually very revealing and frequently become self-portraits of their creators. Creating their monster allows clients to observe, explore and discuss methods of dealing with fears and anxiety.

2. This group is frequently dynamic and insightful for clients. The clay allows for release of tension and energy. I've observed people squeezing the clay and pounding it as they molded family members.

 During one group art therapy a female client in her early twenties named Jane portrayed her family sculpture as one large phallic structure. Her mother had died and her father had just remarried. As Jane spoke about her father she held her sculpture and appeared to be masturbating it. As she became verbally more and more angry with her father, she stroked the sculpture faster and faster. The stroking stopped when she finished sharing her feelings about her father's relationship with her stepmother. Jane sighed after sharing her emotions and seemed to relax. It was as if she brought the clay image to orgasm. The symbolism was extremely potent and reflective of the client's strong emotions toward her father.

 Another depressed client named Emma was stunned upon viewing her unrealistic family sculpture. Part of her problem was her relationship with her sons, domineering them and mothering them although they were adults and over six feet tall. Her sculpture revealed small boys half her size. Emma stated that she was "surprised" that she sculpted them that way and "would not have noticed if it hadn't been pointed out to her." She had to admit that a large part of her problem was treating her grown sons like those sculpted little boys.

 During the same art therapy session another woman depicted her 35-year-old daughter as a little girl. She was awakened into realizing that her daughter was an adult and that it was time to treat her like one.

 Family sculptures increase the client's awareness of family dynamics and his or her role in the family.

3. Model Magic is a type of clay that is very pliable and pleasant to work with. It does not have an odor and it is a clean clay – color does not rub off on one's hands.

4. From "Pinch pot," by P. Berensohn (1976), p.239, in A. Robbins and L.B. Sibley (eds) *Creative Art Therapy*. New York: Brunner/Mazel Publishers.

Combining Modalities

Combining fine art (drawing, painting, etc.) with other modalities brings forth a wealth of areas for creative expression. Poetry and music, for example, in combination with fine art, enhance sensory stimulation and the expression of feelings and ideas. Dance/movement combined with drawing and/or painting provides a rich forum for clients to share issues and concerns. They may move their bodies in a certain way and then draw that movement. In this way clients can explore symbolism represented through both their movements and their drawings. They may look for similarities and/or discrepancies in the way they represent themselves using these creative approaches.

One method of presenting a poetry and art group is to have one client read a specific poem, which is then discussed by group members. Clients are asked to draw what the poem means to them; and/or illustrate meaningful phrases, ideas, etc.

Drawing to Music

Materials:

Recordings of various melodies, paper, pastels, markers

Procedure:

A lively, somber, and then a mellow song may be played. While each song is played clients are encouraged to draw their feelings to the music.

Discussion/Goals:

Discussion focuses on examining feelings and memories evoked by the music. Goals include the expression of issues and concerns.

Movement and Sculpture

Materials:

Clay or wire

Procedure:

Have clients create a figure doing something (dancing, jumping, sitting, etc.). When it is time to share the sculpture, encourage participants to move or pose like their figure.

Discussion/Goals:

Discussion focuses on how clients relate to their figures, which individuals are willing to pose or move like their figures, and which individuals are reluctant to move. Self-awareness and self-esteem are explored.

The Blues[1]

Materials:

Taped blues music or someone who can play the guitar, paper, craypas, markers

Procedure:

Discuss the blues, and what the blues mean for each group member. Now have clients draw their "blues." Next suggest clients make up a group blues song (ideas can be taken from each individual's artwork). Each client contributes one line or verse; he or she is encouraged to sing the verse. The guitar player strums, or the taped music plays, in the background.

Discussion/Goals:

Goals include the projection of troubling issues, and the expression of thoughts, fears and concerns. Discussion may focus on expressing one's blues, and problem solving.

"The Road Not Taken"

Materials:

Drawing paper, markers, etc.

Procedure:

Read the poem "The Road Not Taken" by Robert Frost[2]. Participants are encouraged to discuss the meaning of the poem. They are then asked to draw the road they took in life and the road they didn't take. (If the group is not well focused you could just have them draw the road that *was* taken.) Individuals are asked to draw symbols representing life events on both roads (e.g. perhaps a wedding gown and children representing the road taken, a painter's easel representing the road not taken).

Discussion/Goals:

Clients discuss which road they chose in life and their feelings about their choice. They also discuss the road not chosen. Individuals assess their life and reflect upon accomplishments and regrets, and explore future plans.

Group Story

Materials:

Blackboard (if available) or large sheet of paper or oak tag, markers

Procedure:

Encourage group members to think of a theme for a group story. Next have each client contribute a sentence to the story. For example, the first participant says, "There was once a family who went on vacation." The second participant continues the story by saying, "They drove through the desert and their van broke down." Then the next person continues until the story is complete. When the story is finished clients are asked to draw their feeling about the story or draw part of the story that they can relate to, or that evokes a strong feeling.

Discussion/Goals:

Discussion focuses on how group members feel about the story, and how they feel about their contributions to it. The meanings symbolized in the

artwork is also explored. Goals include focusing, socialization and problem solving.

Expressing Feelings

Materials:

Instruments (or items which make noise, such as two sticks, a large can, metal lids from baby food jars placed in a plastic Ziploc bag, etc.), drawing paper, markers

Procedure:

Ask clients to draw a variety of feelings. Next have them express one of the feelings through music. Encourage them to use their instrument to represent a feeling (for instance, they may bang the drums if they are angry or frustrated, or gently tap the triangle if they are feeling mellow or in high spirits). They may also sing, whistle or hum.

Discussion/Goals:

Discussion involves exploring feelings, and methods of communicating with others. Goals include self-expression, self-awareness and socialization.

Exploring Relationships

Materials:

Drawing paper, markers

Procedure:

Instruct clients to draw a problematic relationship they are having or have had in the past. Have them recreate their drawing by choosing group members to pose as different people in their lives. The client will instruct the individuals he or she chooses to say what he or she thinks his or her friends, family members, etc. would say. He or she may pose the participants and encourage them to move about the room as he or she sees fit. The client explains his or her problem through the models.

Discussion / Goals:

Discussion focuses on both the artwork produced and the role playing. Clients express relationship issues and problem solve. By choosing who should be models and controlling their movements, and what they say, clients gain mastery over their problems. They explore ways to relate better and communicate with others.

Notes

1 This art experience has proven to be therapeutic as well as fun. Sometimes clients are reluctant to sing at first, but they relax and participate when they understand they are working as part of a team. Live music, if it's possible to have it, enhances the group experience. This project is recommended for adolescents and higher-functioning clients.

2. This poem is a favorite of many clients. It is easy for them to understand and relate to.

Mandalas

The drawing of mandalas has proven to be insightful and therapeutic experiences. Before we look at ideas for practice, here is a brief explanation of mandalas and their healing qualities, as stated by Jung.

The Sanskrit word "Mandala" means "circle" in the ordinary sense of the word. In the sphere of religious practices and in psychology it denotes circular images, which are drawn, painted, modeled, or danced. As psychological phenomena mandalas appear spontaneously in dreams, in certain states of conflict, and in cases of schizophrenia. As a rule, mandalas occur in conditions of psychic dissociation or disorientation. As per Jung (1972, p.3):

> the severe pattern imposed by a circular image compensates the disorder and confusion of the psychic state – namely, through the construction of a central point to which everything is related, or by a concentric arrangement of the disordered multiplicity and of contradictory and irreconcilable elements.

This is evidently an attempt at self-healing. Individual mandalas make use of a well-nigh unlimited wealth of motifs and symbolic allusions from which it can easily be seen that they are endeavoring to express either the totality of the individual in his inner or outer experience of the world, or its essential point of reference. The mandalas often represent very bold attempts to see and put together irreconcilable opposites and bridge over apparently hopeless splits.

Mandalas

Materials:

Crayons, pastels, paper plate, drawing paper

Procedure:

Have clients trace a circle from a plate or draw their own circle free-hand. Ask them to color in the circle starting in the center and working their way toward the periphery of the circle.

Discussion / Goals:

Goals include centering, focusing and expression of feelings through design, color and images.

Mandalas. A 25-year-old depressed woman drew this mandala, which she describes as "cheerful, hope for the future." She said the flowers (located on the 2 outer circles) represent growth, love and beauty. She is hoping to find love one day; all of her past relationships have been "disasters."

The mandala on the front cover of the book was drawn by a 23-year-old female suffering from bipolar disorder, and is titled "The Eye." The client remarked that sometimes she feels like everyone is watching her, trying to see if she will "slip up." She stated the sharp, triangular legs represent her desire to walk away from her illness. The red spikes (on the outer rim of the pink circle) and the green spike-like shapes attached to the triangular legs symbolize danger.

Group Mandala Mural[1]

Materials:

Mural paper, paper plates, craypas, pastels

Procedure:

Group members trace a big circle, and draw individual mandalas within it on one large sheet of mural paper.

Discussion / Goals:

Goals include centering, socialization, sharing with others, and defining and recognizing boundaries. Discussion focuses on the design and meaning of the mandalas and placement of them.

Mandala Collage

Materials:

Paper plate, drawing paper or construction paper, markers, scissors, glue, magazines

Procedure:

Clients use a plate to trace a circle onto white drawing paper or construction paper. They are instructed to fill in the circle with pictures from magazines that they find meaningful. They may title the mandala if they so desire.

Discussion / Goals:

Discussion focuses on the meaning of the collage and the manner in which it is designed. Goals include focusing, centering, problem solving, and expression of feelings.

Circle of Emotion

Materials:

Coffee can lid or circle of a similar size, markers, crayons, craypas, pastels, drawing paper

Procedure:

Have clients use the coffee can lid to trace a circle onto a sheet of paper. Ask participants to draw an emotion using color and design inside the circle. Then instruct clients to create an environment around the circle. An example of an environment might be a park-like setting surrounding a mandala that represents peace and harmony, or a thunderstorm surrounding a mandala that symbolizes anger.

Discussion/Goals:

Discussion focuses on the relationship between the mandala and its background. Goals include focusing, centering, and the expression of emotions and feelings.

Note

1. Another variation of this mural is to have clients draw individual mandalas, cut them out and glue or tape them to a large sheet of mural paper. They may draw an environment around their mandala or create an environment for all the mandalas (the group can decide how to proceed).

Portraits

Creating various types of portraits and self-representations allows the client to focus on himself/herself, his or her appearance, body image and attitudes. It allows the client to gain more insight into his or her actions, motives, and relationships with others.

During these sessions feedback from group members is extremely valuable for clients, who frequently recognize aspects of themselves that have gone unnoticed or were previously denied.

Self-Portraits

Materials:
Drawing paper, pastels, crayons, markers

Procedure:
Instruct clients to draw themselves (realistic or abstract representations).

Discussion/Goals:
Discussion focuses on the manner in which the artist depicted himself/herself, and his or her associated thoughts and feelings. Goals include exploration of self-esteem and self-awareness.

Self-Portraits: Exploring Emotions

Materials:
Drawing paper, paint, crayons, pastels

Procedure:
Ask clients to fold their papers into thirds. In the first section have them draw themselves joyful, in the second section have them draw themselves sad, and in the third section have them sketch themselves angry.

Discussion/Goals:

Discussion focuses on examining various emotions, and exploring self-image and coping mechanisms.

Self-portrait. Drawn by a 75-year-old woman suffering from depression and anxiety, who never married and has no children. She said this represents her optimism and sense of humor. Another client remarked that the sketch looked like two fetuses. The artist sighed and agreed, then began talking about her regrets regarding never having had children and the loneliness she feels. She stated she feels cheated.

Cake Box Portraits

Materials:

Cake boxes (can be purchased at many art supply and party supply stores; some bakeries will sell them at a nominal cost), markers, craypas

Procedure:

On the inside of the flattened box have clients draw how they see themselves; on the outside of the box have them draw the way they think others see them. Instruct clients to put the box together and then allow them to add anything to the inside of the box that is self-representative.

Discussion/Goals:

Discussion focuses on self-awareness and self-esteem. Individuals explore how they see themselves and how other people see them. Similarities and differences are examined.

Body Tracings

Materials:

Large sheets of mural paper, pastels, crayons or craypas, masking tape

Procedure:

Have each participant hang a sheet of paper the size of themselves on the wall. Ask clients to take turns standing with their bodies pressed against the paper while another client draws their body outline on the paper. The client then fills in his or her body outline, however he or she pleases. If wall space is not available clients may trace the outline of their body while lying on a sheet of paper placed on the floor (this method of presentation is more threatening than standing; it may be used if the client is willing to stretch out on the floor for a moment or two, and is high functioning).

Discussion/Goals:

Discussion focuses on the figure drawn, its appearance, and its style:

- What type of clothes are drawn?
- Is it a young person or an older individual?
- Is it a hippie, a punk rocker?
- Is it realistic looking or cartoon-like?
- Does it look like the artist or totally different?

Questions such as, "Does this figure remind you of someone you know?" may be asked. Clients may be asked to stand next to the figure they find most friendly or appealing. This exercise generates a lot of discussion regarding friendships, popularity and relationships. Goals include socialization, self-awareness and exploration of body image and self-esteem.

Draw a Group Member Whom You Admire

Materials:

Drawing paper, craypas, markers

Procedure:

Draw a group member of whom you think highly. The portrait may be realistic or abstract. On the back of the portrait draw and/or write why you admire him or her.

Discussion/Goals:

Discussion may focus on whom each client chooses to draw and why he or she chose that person, the qualities of the individual chosen, and the way the portrait reflects the personality of the individual drawn. Goals include socialization, self-awareness, and exploration of one's position in the group.

This project has proven successful when clients are comfortable with each other and have been in a variety of groups together. Clients appear to enjoy this activity and become very involved and focused when the artwork is shared. It is of interest to note that clients often draw portraits of others which are indeed representative of themselves. Clients often project their attitudes and feelings onto these portraits. Much insight and growth is derived when this projection is clarified to the clients by other group members and/or by the therapist.

Ideal Self

Materials:

Drawing paper, markers, crayons

Procedure:

Ask clients to draw themselves as they wish they were, their ideal self. This "perfect" self may be represented by appearance, clothes, and attitude (facial expression), etc.

Discussion/Goals:

Discussion focuses on examining the differences between the client's ideal self and his or her real self. Methods of becoming more content and increasing one's self-esteem are explored.

CHAPTER 13

Group Work

Projects involving group work are beneficial in that they aid in exploring and enhancing socialization and communication skills. Clients examine how they interact with others and how others interact with them. One's role in the therapy group often relates to one's role in family and/or other social relationships. If an individual is quiet and withdrawn during group work he or she usually shares that he or she is also reserved with friends, family, etc. Observing and examining his or her communication style allows the individual to understand better his or her relationship style and any communication problems with significant people in his or her life.

Group work is often less threatening than individual work. The client is not singled out, as he or she often is when he or she shares his or her individual artwork. He or she is not solely responsible for the outcome of the artwork; the entire group is the artist. Many individuals find comfort in this and enjoy working with peers, and sharing thoughts and ideas.

Design a Group Vacation

Materials:

Markers, craypas, a large sheet of mural paper, masking tape

Procedure:

Clients are asked to decide where they would like to go on vacation. They decide what city, state, country, etc. to visit, how they will get there (car, train, plane, etc.), how much the vacation will cost, where they will stay (hotel, motel, etc.) and how long the vacation will be. They decide what they will do on vacation (sightsee, relax by the beach, etc.).

123

Discussion/Goals:

Discussion includes examining the artwork and how it represents the group vacation. Goals include improving socialization, communication, and problem solving skills. Learning to work together is focused upon.

Group Clay Pass

Materials:

Clay (Model Magic is good to use for this: It is not drying, leaves no residue or color on one's hands, and feels soft and pliable

Procedure:

Everyone takes a turn (a minute or two) manipulating and molding the clay. Each person then tells the group how the clay feels (soft, squishy, cold, etc.) and what feelings it evokes. The clay is then passed around a second time and each person takes a turn molding the clay into a realistic or abstract sculpture.

Discussion/Goals:

Clients discuss emotions, issues and feelings. Group cohesiveness is emphasized. Goals include focusing and abstract thinking.

Group Fruit Bowl

Materials:

Papier mâché paste[1], paint, newspaper, paper towels, scissors, wire, plastic bowl, sandpaper

Procedure:

Clients are instructed to design a fruit bowl together out of *papier mâché*. One group member may be selected to be the group leader and assist group members in designing the bowl. There are a variety of methods that may be used to create the bowl. Wire may be used to form an armature for the bowl and then *papier mâché* strips may be used to cover the armature. An easier method of designing the bowl is to find an old bowl or purchase one in a dollar store. Wet newspaper strips with *papier mâché* and cover the bowl. Let the bowl dry. Next have each client choose

his or her favorite fruit to contribute to the group bowl. Clients mold their chosen fruit out of *papier mâché* and let it harden overnight. Wet paper towels may be used to form the shape of the fruit. The *papier mâché* strips are then put on top of the paper towel mold. (Using wire to form the outline of the fruit is another possibility.) When dry, clients sandpaper the fruit until the texture is pleasing, and realistic-looking. The fruit and the bowl are then painted, and the fruit is placed in the bowl.

Discussion/Goals:

Discussion focuses on each person's contribution to the fruit bowl, each person's experience working as a team on this assignment, and reactions to the completed project. Goals include socialization, group unity and interaction, the structure and enhancement of ego functioning through participation and the bringing of the project to completion. Reality orientation and focusing of attention are desired goals. Group dynamics may be observed and explored.

Group Diorama

Materials:

Large carton or cardboard box, paint, glue, scissors, clay, construction paper

Procedure:

Ask clients to think of a theme for their diorama, for example "A Day In The Park," or "The Family Gathering." Encourage individuals to decide how best to approach creating the scene, using paint *vs* construction paper, clay figures *vs* paper figures. Encourage them to think about people, items, animals, trees, etc. that will be part of the scene. Ask group members to decide whether to design the outside or inside of the box first. Next encourage clients to work together to create the actual scene using the materials listed above.

Discussion/Goals:

Discussion may center on how well clients worked together and their reactions to the finished project. Group dynamics may be explored (who

takes control, becomes leader, etc.). Each person's contribution to the diorama may be examined. Goals include socialization, increased communication with peers, creative thinking, and problem solving.

Client Community

Materials:

Large sheet of mural paper, cardboard, markers, paint, construction paper, glue, scissors

Procedure:

Clients are instructed to design three-dimensional cardboard houses. Depending on the population, the clients may design their own house or the group facilitator may provide cut-outs of the frame and roof of the houses. The clients may then be shown how to glue or tape the pieces together in order to design the completed form. The structures may be painted or construction paper may be used to decorate them. When the houses are completed participants are asked to place them on the mural paper (the bottom of the houses may be taped down to the paper if desired) in order to form a community, which may include trees, cars, etc. Roads, bridges, grass, etc. may be drawn on the paper.

Discussion/Goals:

Discussion focuses on the community, where the houses are placed, how the houses are designed, and ways in which the house represents the artist (is the house large/small, weak/strong?). Relationships may be explored:

- Where is the house located?
- Are other houses near it?
- Is it in the corner and away from the other structures?

Clients are given the opportunity to design and manipulate their environment; they are in control.

Draw the Group

Materials:

Drawing paper, markers

Procedure:

Clients are asked to draw the group in any way they please.

Discussion/Goals:

Discussion might focus on individuals' positions in the group, and relationships. Goals include self-awareness and focusing on the here and now.

Miniatures Box

Materials:

Cardboard or wood box with many small compartments, paint, glue, clay

Procedure:

The group thinks of a theme for the compartmentalized box. Each client chooses a compartment (sort of their own mini-box) within the large box, and designs it in his or her own way. He or she may add clay figures, paper scenery, etc. Clients are told that they may utilize their space in any way they please, but that it should relate to the other compartments in some way (follow the theme).

Discussion/Goals:

Discussion focuses on relationships, working together as a group, communication with others and making connections. The client has the opportunity to manipulate his or her part of the environment while learning to be part of a whole.

Group Drawing Pass: Drawing Someone Special

Materials:

Drawing paper, crayons or markers

Procedure:

Have clients choose one specific color crayon or marker. He/she works only with this color during the entire session. In this way the clients will easily recognize the figures they have drawn on each sheet of paper. One sheet of paper is passed to each individual. Clients are asked to draw a special person in their life on each sheet of paper that is passed to them. He/she may include friends, family members, teachers, religious leaders, etc. Each person draws on his or her sheet of paper for about two or three minutes and then the group leader says "pass" and each client gives the person to his or her right his or her sheet of paper. Now each individual draws on the paper that was passed to him or her and the drawing continues in this manner. This goes on until each person has had a chance to draw on everyone's else's sheet of paper. The drawing pass is complete when the group members receive their original drawing back, complete with each participant's unique sketches.

Discussion/Goals:

Group members will explore the meaning of their pictures, and they will look for similarities and differences in the various drawings. The need for relationships and significant others in one's life may be explored. Goals include working together as a means of fostering socialization and communicate.

Note

1. See note 2 to Chapter 7 for a recipe for *papier mâché*.

CHAPTER 14

Holiday Projects

Participating in unique art experiences on special occasions and holidays gives clients the chance to celebrate and examine their feelings regarding the occasion/holiday. It affords clients the opportunity to vent feelings about being in an inpatient or partial program during times of celebration. Clients may choose to express holiday sentiments; they may share frustration and sadness because of their lack of friends or family with whom they can celebrate. Many individuals become increasingly depressed at holiday time; they need to express their sadness in order to cope better with their situation and avoid increased anxiety.

Some clients wish to ignore holidays such as Christmas and New Year's; others need to discuss feelings associated with these occasions and, in some way, celebrate and acknowledge them. The art therapy group provides this opportunity.

Holiday Stockings

Materials:

Construction paper and/or felt, glue, yarn, sequins, markers, scissors

Procedure:

Encourage clients to design stockings out of felt or paper. Depending on the client population, the group facilitator may provide a stocking pattern for participants to follow. The clients may decorate the stockings in any way they wish. When the stocking is completed, ask participants to draw (on pieces of paper small enough to fit into the stockings) what they'd like to see in their stockings this holiday (e.g. a new car, money, health, happiness). Group members are encouraged to share their thoughts by

taking the papers out of the stockings one by one, and speaking about the item or wish they have represented on the paper.

Discussion/Goals:

Discussion focuses on the holiday season, wishes and goals, and methods of achieving them. Goals include socialization, sharing with others, and the expression of thoughts and feelings.

Designing Wreaths

Materials:

Paper plates, yarn, felt, ribbon, sequins, buttons, scissors

Procedure:

Instruct clients to cut out the center of a paper plate and use the remainder of the plate for the wreath base. Have participants wrap yarn around the base (in an over-and-under pattern) and then decorate with one or more bows and sequins/buttons, etc.

Discussion/Goals:

Discussion may focus on feelings about the holiday season and the ease or difficulty involved in creating the wreaths. Goals include focusing, problem solving, and the expression of feeling; invariably thoughts about the holidays will surface.

Paint Your New Year's Resolutions

Materials:

Drawing paper or any other type of paper that is conducive to paint, acrylics, and/or tempera paints

Procedure:

Encourage group members to discuss their feelings about the New Year and to then paint their resolutions.

Discussion / Goals:

Discussion and goals focus on sharing clients' resolutions and exploring methods of achieving them.

Easter: Egg Sculpture

Materials:

Eggs (a few dozen), wire, glue, paint

Procedure:

The group facilitator and/or group members should poke a hole on both sides of each egg using a thick needle. Then the clients are instructed to blow out the yolks into paper cups (if they don't wish to do this the group leader may do the job). When the eggs are hollow they may be decorated with paint. Clients decide if the sculpture will be realistic or abstract. The group decides how to best attach the eggs together (combining wire and glue works well) to create a sculpture pleasing to them.[1]

Discussion / Goals:

Discussion focuses on the sculpture (how it was designed, the colors, and meaning behind it), the ease or difficulty involved in creating the sculpture and how participants dealt with frustration (if they found it difficult to construct). Goals include socialization, problem solving, sharing, and the expression of thoughts and feelings.

Valentine's Day Collage

Materials:

Construction paper, glitter, felt, cotton, feathers, doilies, sequins, markers, glue, scissors, a variety of textures and materials

Procedure:

Ask clients to design a collage using the various textures and materials to represent what Valentine's Day, love, relationships, and/or friendship mean to them.

Discussion/Goals:

Discussion may focus on exploring relationships and feelings associated with the holiday. Goals include self-expression, focusing, problem solving and abstract thinking.

Valentine's Day: Heart Magnets[2]

Materials:

Small wooden heart shapes (found in art supply stores), acrylic paint, sequins, small buttons, tiny circular magnets

Procedure:

Instruct clients to paint the wooden hearts in any way they please. After the paint is dry they may glue on decorations. Next they glue the magnet backing onto the heart and let dry.[3]

Discussion/Goals:

Goals include focusing and creative expression. Discussion may center on thoughts regarding the holiday, and reactions to how clients designed their magnets.

The "February Blahs"

Materials:

Drawing paper, markers, crayons

Procedure:

Ask clients to draw what the "February Blahs" mean to them. Discuss methods of dealing with this "malady."

Discussion/Goals:

During the long winter months many individuals become weary of the short days and cold and often dreary weather. Sometimes the weather has a negative effect on these individuals. They may become increasingly depressed and anxious. This project gives clients the opportunity to reflect on their feelings and try to find solutions to their depression. This project can be adapted for use during any month or time of the year.

Saint Patrick's Day: Draw a Four-Leaf Clover and a Wish

Materials:

Drawing paper, markers, craypas, crayons

Procedure:

Do a brief guided imagery with clients. Ask them to close their eyes and pretend that they are walking in a lovely field. The sun is warm and welcoming and the grass is very green and soft. There are many flowers dancing in the breeze; the fragrant scent of the flowers is everywhere. You bend down and begin picking pansies, petunias, daisies, and marigolds. All of a sudden you notice a bed of clover, and one special clover catches your eye; it is a four-leaf clover. "What luck," you think. You quickly pick it, close your eyes and make a wish.

Now ask clients to fold their paper in half; on one side have them draw the four-leaf clover and/or the field of flowers, and ask them to draw their wish on the other side of the paper.

Discussion/Goals:

Clients are encouraged to share their artwork and explore how their wish reflects certain wants and needs. Goals and hopes for the future may be examined.

Notes

1. This can also be done with hard-boiled eggs, but they are more difficult to attach and build upon. Glue may be used to connect them.

2. This project may be utilized during various seasons and holidays. For example, small wooden snowman shapes could be painted during the winter months, and Menorahs and candy cane shapes could be designed to represent Chanukah and Christmas.

3. Instead of gluing a magnet to the wood some clients may wish to glue a pin back to it in order to create decorative jewelry.

Stress Reduction

Drawing, painting and sculpting help individuals relax; they become more focused and centered. The act of creating can be cathartic; energy is used in a constructive manner and tension is released. The artist isn't thinking solely about worries and concerns; he or she is concentrating on the task at hand. It is a way to unwind and free oneself from life's stressors.

Various art experiences may center on stress management; the goal being decrease of anxiety and tension. The artwork created, as well as insights from group discussion, may aid in finding new methods of coping with worry, depression and fear.

A Soothing Picture

Materials:

Drawing paper, pastels, craypas, crayons, markers

Procedure:

Ask clients to think of a time they felt relaxed and at peace. Request that they think about where they were, whom they were with and how they felt at the time. Next ask group members to create that feeling on paper. Instruct them to use calming colors and shapes.

Discussion/Goals:

Discussion focuses on the tranquility represented in the artwork. Methods of attaining a calm state may be explored. Goals include stress reduction and the exploration of coping skills.

Relaxation Exercise and Collage

Materials:

Construction paper, collage materials (feathers, pipe cleaners, pom poms, buttons, etc.), scissors, glue, markers

Procedure:

The group facilitator leads a simple relaxation exercise. Clients are invited to relax, close their eyes and take a few deep breaths. Starting from their head to their toes have them tighten and relax various parts of their body. They might be asked to tighten and then relax their eyes, nose, mouth, neck, shoulders, arms, hands, stomach, buttocks, legs, feet and toes. When the exercise is over ask clients to create a collage representing the peaceful state they felt during the relaxation experience.

Discussion / Goals:

Discussion focuses on the way in which the collage represents tranquility for each individual. Goals include focusing, abstract thinking, the exploration of relaxation techniques and coping skills.

Colored Paper Collage

Materials:

Drawing paper, construction paper and various types of decorative paper (glossy, patterned, origami paper), glue, scissors

Procedure:

Ask clients to cut out shapes of various colors that give them a peaceful feeling. Instruct clients to glue these shapes on the paper of their choice.

Discussion / Goals:

Discussion focuses on the artwork and the tranquility portrayed in the collages. Goals include exploring methods of attaining the peace represented in the collages.

A Healing Picture

Materials:

Drawing paper, markers, pastels, crayons, craypas

Procedure:

Discuss the idea of healing (e.g. putting an antibiotic and a band aid on a wound helps it heal). Ask group members to draw a picture that helps heal them from past worries and concerns.

Discussion/Goals:

Discussion focuses on the way healing is symbolized in the artwork. Clients share strategies to help mend old wounds. Goals include problem solving and exploring coping skills.

Food to Soothe

Materials:

Drawing paper, markers, craypas, crayons, pastels

Procedure:

Suggest that clients draw food/s that help them relax and comfort them.

Discussion/Goals:

Discussion centers on the food drawn and the degree of comfort it provides for the individual. Methods of attaining the same peaceful state when one is not eating are explored.

Exploring Stress

Materials:

Small bucket, markers, craypas, crayons, pastels

Procedure:

Suggest that clients draw their stress (realistic or abstract). After it is drawn ask them to cut it out. Place a bucket in the center of the table. Clients are then requested to share their symbolic stress (their artwork).

They have the choice of holding on to it or throwing it out (throwing it in the bucket).

Discussion/Goals:

Discussion centers on exploring each person's stress and how he or she handles the stress. Goals include stress reduction, self-awareness, and problem solving. Clients are encouraged to take responsibility for their anxiety and worries, and to explore coping skills.

Draw Yourself Relaxing

Materials:

Drawing paper, markers, etc.

Procedure:

Clients are asked to draw themselves doing something relaxing (e.g. reading, exercising).

Discussion/Goals:

Clients discuss methods of relaxing (breathing techniques, yoga, etc.) and ways in which one can attain a relaxed state during stressful times.

Tension Drawing

Materials:

Drawing paper, markers, craypas, crayons

Procedure:

Ask clients to close their eyes and breathe deeply. Suggest that they listen to their bodies for a few minutes (they may listen to their heart beating, stomach grumbling, the sound of their breathing, etc.). Ask them to focus on how they feel (are they comfortable, are they experiencing any aches, any tension in their body?). Encourage them to draw any tension or any stiffness they feel.

Discussion/Goals:

Discussion focuses on where the tension is and methods of decreasing the stress and discomfort. Goals include self-awareness and exploring coping skills.

Exploring Tension

Materials:

Drawing paper, markers, craypas, crayons

Procedure:

Ask clients to fold their sheet of paper in half. On one side of the paper instruct group participants to draw a tense figure and on the other side of the paper suggest that they draw a relaxed figure.

Discussion/Goals:

Discussion focuses on comparing and contrasting the two figures, and exploring how stress affects one's body, emotions, and attitudes. Group members may explore their individual styles of handling stress.

Floating on a Cloud

Materials:

Drawing paper, markers, craypas, crayons, cotton if desired, tape or CD of soothing music

Procedure:

Play soothing music. Ask clients to imagine themselves floating on a cloud. Suggest they think about the size of the cloud, its texture, and their thoughts and feelings. Ask them to think about the sights, sounds and scents they experience. Have them draw themselves on the cloud. Participants can draw the cloud or use cotton to create it.

Discussion/Goals:

Discussion focuses on exploring clients' reactions to the brief guided imagery and their artwork. Methods of attaining the calm that one would

feel floating on a cloud might be explored. Goals center on exploring stress reduction techniques.

Pastel Design

Materials:

Drawing paper, pastels, tape or CD of mellow music

Procedure:

Play mellow music and ask clients to spread lightly the pastels on the paper. They may sway gently as they do this. Encourage participants to let their fingers take them wherever they please. Tell them not to think of a design or theme; they should just move freely and create an image to the music.

Discussion / Goals:

Discussion focuses on the feelings experienced while spreading the pastels on the paper (usually group members feel peaceful and carefree while designing with the pastels). Ask group participants to discuss their stress level while doing this exercise. Explore who felt relaxed and who felt anxious. Art as a method of stress reduction might be explored.

Free-Floating Shape

Materials:

Drawing paper, markers, craypas, pastels, crayons

Procedure:

Ask clients to draw themselves as a free-floating shape. Suggest that they title their design.

Discussion / Goals:

Discussion focuses on exploring the size, color and appearance of the shape. Explore how the shape relates to the artist (e.g. a tiny box might represent a rigid, withdrawn individual). Goals include examining ways in which participants can attain a relaxed state and feel a sense of freedom and flexibility.

Positive Images

Materials:

Drawing paper, pastels, markers, craypas, crayons

Procedure:

Suggest that group members think of as many positive images as they can, and represent them in any way they wish on the drawing paper.

Discussion/Goals:

Discussion focuses on the images and the positive feelings associated with the images. The relationship between thinking optimistically and better mental and physical health is explored.

Hobbies and Leisure Pursuits

Materials:

Drawing paper, markers, craypas, crayons

Procedure:

Discuss how leisure pursuits can help individuals relax, become focused and centered, and feel better about themselves. Explain that engaging in hobbies often decreases stress and anxiety. Ask clients to draw activities that they find enjoyable and which help them unwind.

Discussion/Goals:

Discussion focuses on activities that reduce anxiety and increase self-esteem. Coping mechanisms are examined.

Miscellaneous

The following projects are a pot pourri of ideas I have found useful in my work with clients. Self-awareness, socialization and expression of thoughts and feelings are major goals. Creative thinking is encouraged when individuals participate in these art experiences. This is important because when one is able to think creatively (abstractly) one is empowered. The individual is then able to observe life from many angles; he or she learns that everything/every situation is not black and white. When a client is able to see the gray areas in life he or she is able to communicate better with others and to deal more effectively with family and friends.

Memory Book

Materials:

Paper, stapler, markers, crayons, craypas, construction paper, scissors, felt

Procedure:

The group leader folds about six sheets of white bond paper in half and staples the paper together in order to create a small booklet. Each group member receives a booklet. Participants are asked to draw their earliest to most recent memories, taking up one page for each memory. They may design the cover in any way they wish (materials such as felt and construction paper may be used for decoration).

Discussion/Goals:

Discussion focuses on the memories and how they are represented in the booklet. The concept of change in one's life may be examined. Goals include self-awareness, communication of feelings, and focusing.

Potato Prints[1]

Materials:

Potatoes, ink, paper, carving tools

Procedure:

The group leader cuts potatoes in half before the group begins and has clients cut a design into the potatoes. Plastic tools are recommended. Clients are then instructed to dip the potatoes in ink and place them on the paper to create a print. Participants may elaborate on the print with pen and ink. They may use the print for practical purposes such as for personalized stationery.

Discussion/Goals:

Discussion focuses on feelings about participating in this art experience, and thoughts/reactions to the prints. Clients may be asked if the prints are realistic or abstract, and if they have special meaning. Goals include focusing, problem solving and ego building (this is a success-oriented project).

Paper Mosaics

Materials:

Construction paper, glue, scissors, markers

Procedure:

Have group members cut out small squares of construction paper (or provide already cut pieces) and ask them to create an image or design using the squares. Markers may be used later to elaborate further on the design.

Discussion/Goals:

Discussion focuses on the meaning of each design, colors used, and method of presentation. Goals include expression of feelings, focusing and problem solving.

Personalized Wooden Plaques[2]

Materials:

Long, thin, flat boards of wood, markers, paint, sandpaper

Procedure:

Ask clients to sand the wood; then ask them to design their own personalized plaque without including their name. Tell them to use colors, shapes, and symbols to represent themselves. Suggest they imagine creating the type of plaque that one might use on an office door. Recommend that they design it using paint and/or markers.

Discussion/Goals:

Discussion focuses on how group members represented themselves; self-esteem may be explored. Goals include increased self-awareness, problem solving and focusing.

Scratchboard and Magic Pictures[3]

Materials:

Crayons, India inks, stylus, cardboard

Procedure:

Ask clients to paint a picture with colored inks or crayons, and to cover it with black crayon. They are then allowed to scratch away a design with the stylus.

Discussion/Goals:

Goals include sure success, expression of feelings, and concepts of addition and subtraction.

Cardboard Tube Time Line

Materials:

Cardboard tubes from empty rolls of paper towels, markers, craypas, colored pencils

Procedure:

Clients are each given a cardboard tube. Many of these tubes have horizontal lines going around them (about eight lines in all; they are about two inches apart). Clients are asked to draw significant parts of their life in each of these two-inch horizontal spaces, starting from their earliest memories. They do this bottom up. The finished product looks like a totem pole.

Discussion/Goals:

Discussion focuses on reviewing one's life and exploring significant events that affect one's personality and behavior. Strengths and positive experiences may be examined.

Flower Dedication

Materials:

Construction paper, black markers, crayons, craypas, mural paper, masking tape, glue, scissors

Procedure:

Group members are instructed to design a flower out of construction paper and then cut it out. (The group facilitator can create these flowers or the clients can design them depending on the population.) The group participants may use markers or craypas to decorate the flowers. Then they are instructed to place the flowers on the mural paper and dedicate them to someone special in their lives.

Discussion/Goals:

Clients may talk about people they care about and who support them. Relationships are explored. The effect of these relationships on one's life is examined.

Personality Box

Materials:

Gift boxes (the cardboard boxes used for jewelry from department stores), construction paper, glue, scissors, markers, paint (if desired), pencils, drawing paper

Procedure:

Encourage clients to decorate small gift boxes and then ask them to write three secrets about themselves. Have the clients put the secrets in the box and ask them to share at least one secret with the group.

Discussion/Goals:

Participants are encouraged to share their inner thoughts and to examine the way their thoughts affect their behavior and actions. Exploration of issues and feelings as well as problem-solving techniques may be explored.

Tissue Paper Scene

Materials:

Tissue paper, cardboard, scissors, glue, pen, ink

Procedure:

Using cardboard as the base, ask group members to tear or cut tissue paper into small pieces and paste the pieces on the cardboard (overlap the tissue). Glue mixed with a little water (Mod Podge works well but Elmer's glue is fine) should be placed under and over the tissue paper, creating a hard surface. When the paper is dry, have clients design an image or scene on top of it using pen and ink.

Discussion/Goals:

Discussion focuses on the design created; its meaning and symbolism. This is an easy, ego-building project, which provides structure. Goals include focusing and self-expression.

Finish Picture Design

Materials:

Magazines, drawing paper, markers, crayons, paste, scissors

Procedure:

Ask group members to choose and then cut out a scene from a magazine. Have them glue the picture on half of a sheet of drawing paper. Suggest that clients continue and/or complete the picture on the other half of the paper.

Discussion/Goals:

Discussion focuses on the image chosen, its meaning for the client, and the manner in which the scene was completed. Goals include problem solving and focusing.

Paper Travel Folder

Materials:

Large sheets of Manila paper or white drawing paper, magazines, markers, glue, scissors

Procedure:

Suggest that clients fold the paper vertically three times. On the first fold ask participants to draw or paste a picture of a country, city, state etc. to which they'd like to travel in the future. In each remaining panel ask them to draw a special place to which they have traveled in the past.

Discussion/Goals:

Discussion focuses on sharing life experiences and hopes for the future. Goals include focusing, and the sharing of desires, thoughts and feelings.

What Would You Do?

Materials:

Markers, crayons, drawing paper

Procedure:

Tell clients to think about this scenario: "You are driving in your car and it breaks down. You are all alone and you are in a wooded area that you are unfamiliar with. What would you do?" Divide the paper into four boxes. Ask clients to draw what they would do, step-by-step, in each of the four boxes (the client has the option of creating a fictional character if that is his or her choice).

Discussion / Goals:

Discussion includes sharing the artwork and exploring the ways in which each person chooses to solve the problem. Goals include focusing and problem solving. It is interesting to see who takes an active role in helping him or herself and who is passive.

Group Mobile

Materials:

Pipe cleaners, construction paper, paint, yarn

Procedure:

Ask clients to put a few pipe cleaners together and then connect them. The pipe cleaners can be formed into a variety of shapes, which will become the mobile hanger. Have clients think of a group theme for the mobiles, e.g. happiness or love. On drawing paper participants can paint small theme-oriented scenes or designs; punch holes in these pictures, and attach them to the pipe cleaner base with yarn.[4]

Discussion / Goals:

Discussion focuses on balance and relationships. Balancing the mobile may help clients maintain better balance in their lives. Participants may broaden their view of their environment by creating a mobile that must be viewed from all angles.[5]

Feeling Judgments[6]

Materials:

Drawing paper, crayons, markers

Procedure:

Encourage clients to draw the person they hate, admire, love, and/or envy the most.

Discussion/Goals:

Goals include awareness of feeling projections, and accepting of a wide range of emotions.

Hospital Drawing

Materials:

Drawing paper, pastels, markers

Procedure:

Ask patients to draw a synopsis of their hospital stay (if they are outpatients they may draw a summary of their experience in their particular day program). Suggest they include:

- events that have taken place inside and outside of the hospital
- people they have met
- feelings and changes they have experienced
- any occurrence that has made an impact on them.

Discussion/Goals:

Discussion focuses on discharge plans and future plans, objectives, hopes and dreams. Goals include the expression of thoughts and feelings about leaving the mental health facility.

Memory Drawing Game

Materials:

Drawing paper, markers, craypas, crayons

Procedure:

Ask clients to draw something using their favorite color.[7] When they are finished drawing have them share their design and favorite color with group members. Tell clients to listen carefully to what each individual says, and to try to remember each person's color preference. If the group is high functioning, ask them to attempt to remember what was drawn in addition to the color used. After each client shares his or her artwork he or she is instructed to place the paper on the table, bottom side up (so no one can see the image). Once everyone has had a turn describing their drawing, group members have to guess each client's favorite color and, if possible, the image or scene sketched.

Discussion / Goals:

Discussion focuses on memory techniques, communication skills, and the use of symbolism to understand better peers, relatives and friends. Goals include focusing, developing greater self-awareness, and exploring ways to enhance one's memory.

Arrow Collage

Materials:

Construction paper, scissors, glue, cardboard

Procedure:

Clients cut a variety of arrows (all shapes, sizes and colors) from construction paper. (The client can draw the arrows or the therapist may draw and cut them out beforehand if this is an issue.) At least 10–15 arrows per person are needed. Group participants are asked to arrange the arrows on paper or cardboard in such a way that they represent the direction of one's life (e.g. are all the arrows pointing downwards? are they going in many different directions?). The arrows are then glued onto the paper or cardboard.

Discussion/Goals:

Discussion focuses on exploring one's life direction, goals, and obstacles to achieving one's goals. Objectives include achieving greater self-awareness, focusing and problem solving.

Interior Decorating

Materials:

Pictures of furniture, scissors, drawing paper, glue

Procedure:

Clients are given pictures of furniture (a couch, chairs, a bed, television set, oven, etc.). The group facilitator provides these pictures, which he or she may sketch and Xerox beforehand. Magazine photos could also be used. Clients are asked to cut out these pictures (or the group leader may cut them out beforehand) and glue them on large sheets of drawing or construction paper. Group members glue the illustrations on the paper and then add details (people, accessories, lamps, photos in frames, vases, laundry baskets, shoes on floor, etc.). They may decorate and personalize the room they create.

Discussion/Goals:

Clients are given the opportunity to discuss their homes, and attitudes about their home environment. Objectives include providing clients with the opportunity to make decisions; they decide the placement of the furniture and decorations. In this way clients become interior decorators and decision makers. Group members control the situation. Problem solving, spatial awareness, and focusing are emphasized.

Art Therapy Bingo

Materials:

See procedure

Procedure:

Take a 9"x12" sheet of drawing paper and divide it into 12 boxes. Outline the boxes with black marker. At the bottom of each box write the

name of something that is easy to draw (e.g. a tree, a sun, etc.). On the top of each box make a small circle. Make as many copies of the 9"x12" drawing paper as there are clients in the group. Next take 40 index cards, size 3"x5", and number them, 1–40. The therapist then distributes the paper, and group members are asked to write numbers in the circles on the top of the page (any number 1–40, in any order). The therapist shuffles the index cards and calls out the numbers. Every time he or she calls a number the client looks to see if he or she has written that number in one of the circles on top of his or her page. If he or she has the number that is called he or she has to draw what is written (house, person, etc.) in that square to the best of his or her ability. The first person to fill up his or her boxes across or down wins (a variation of the game is the first person to fill all of his or her boxes wins). The winner has to show everyone all of his or her pictures and describe them. If the therapist desires, a small prize may be given to the winner.

Discussion/Goals:

This is a game clients usually enjoy very much. It is especially popular with an older clientele. It is a very non-threatening way to encourage participants to draw and learn how to sketch basic symbols. Goals include socialization and problem solving.

Create a Collage of Your Utopia

Materials:

Paint, markers, craypas, drawing paper, construction paper, glue, scissors

Procedure:

Clients are asked to choose magazine pictures which represent images of what utopia would be like for them.

Discussion/Goals:

Group members discuss ideal living conditions, methods of attaining goals, and methods of finding satisfaction with their life. Objectives include expression of feeling, focusing and problem solving.

Silly Putty: Childhood Games

Materials:

Silly Putty (remember this putty? It comes in a plastic egg and is still sold in a variety of stores, such as Walmart and art supply stores, as well as many art supply catalogs), drawing paper, markers, crayons, etc.

Procedure:

Clients are given Silly Putty and instructed to experiment with it. They are then asked to express feelings, which emerge as they manipulate the putty. The theme of childhood fun usually surfaces. This theme serves as a transition to the art assignment: drawing one's favorite childhood toy or game.

Discussion/Goals:

Clients might discuss the positive aspects of their childhood while reflecting on the games/toys they enjoyed. Nostalgia is a focus, as well as exploration of past and present hobbies and interests.

Papier Mâché Figures and Animals

Materials:

Newspaper, cardboard tubes, tape, water, flour, sugar, paint

Procedure:

Prepare the *Papier mâché* paste in advance.[8]

Instruct clients to shape an animal or a figure, which entails crumpling newspaper into balls and taping them together to form a head, neck and torso. Attach more crumpled newspaper to shape other rounded body parts. To form legs loosely tape cardboard tubes to the torso. Next tear the newsprint into strips and dip the strips into the paste, remove any excess paste and continue until the entire surface is covered. Apply two more layers of strips and allow the *Papier mâché* to dry thoroughly. Paint the figure.

Discussion/Goals:

Discussion focuses on the figure created and the meaning it has for the artist. Goals include focusing, problem solving and expression of feelings.

Felt Board Design

Materials:

Fabric glue, a large piece of felt (approximately 22"x36"), cardboard (the same size as the large sheet of felt), fabric scissors, assorted 9"x12" felt sheets, self-adhesive Velcro

Procedure:

One felt board is made for each client. Glue the felt onto the cardboard backing to make a felt board. Encourage clients to cut out shapes (realistic or abstract) from the 9"x12" felt squares. Attach a small piece of Velcro to the back of each cut-out and place on the felt board in order to create a scene or design. If the clientele is low functioning the therapist can construct the felt boards and cut out the felt figures beforehand. Group members would only have to place the cut-outs on the board in order to form their picture.

Discussion/Goals:

Discussion focuses on the images created and their meaning. Goals include focusing and problem solving. During this art experience clients have the opportunity to be in control of their art; they can manipulate the parts of the picture until they are satisfied with the results.

Edible Clay (Peanut Butter Play Dough)

Materials:

Peanut butter, powdered milk, honey

Procedure:

Ingredients:

> 2 cups peanut butter

2 cups dried milk

1 tablespoons honey

Mix the ingredients together. Knead the dough until it is pliable and doesn't stick to your hands. Keep adding more dried milk until the clay is workable. Ask participants to work with the clay and design a figure, animal, or abstract structure.

Discussion/Goals:

Clients often have strong positive or negative feelings about the smell and texture of the dough. Discussion may focus on the dough, the designs formed, and what each person decides to do with his or her creation. When someone eats his or her figure, for instance, it sends a powerful message (especially when the figure is a family member or friend).

Affirmation Tree[9]

Materials:

Large sheets of drawing paper, scrap materials, construction paper, crayons, markers, scissors, glue or tape

Procedure:

Encourage group members to decide together how to construct the body of the affirmation tree; for example, whether it will be free-standing, on a large sheet of paper against a wall, or flat on the floor. Group members take turns designing the tree (coloring it in, decorating it). Next each person designs a unique leaf for the tree and writes something positive about himself/herself on the leaf. Participants take turns attaching their leaf to the tree and reading aloud the positive comment written on his or her leaf.

Discussion/Goals:

Discussion focuses on the affirmations and feedback from group members. Goals include increasing self-awareness, self-esteem, socialization and group cohesiveness.

Scent Drawing[10]

Materials:

A variety of scents, tissues, drawing paper, markers, craypas, pastels

Procedure:

The group facilitator dabs scent (perfumes, vanilla, lemon, etc.) on tissues. Clients are given the perfumed tissues and are asked to draw an image that the scent evokes (realistic or abstract).

Discussion / Goals:

Discussion focuses on the scent and the thought or emotion associated with the scent (as illustrated on paper). Goals include increased sensory awareness and the expression of feelings.

Feeling Cards

Materials:

Construction paper, glue, scissors, paint, markers, white drawing paper (8"x10" or 9"x12").

Procedure:

Instruct clients to fold the white drawing paper in half (like a greeting card) and then choose one sheet of construction paper (one color). Have group members cut the construction paper in a square or rectangle so that it fits on the top fold of the white drawing paper leaving a one or two inch border on all sides. Have clients glue the construction paper on the white drawing paper. Then ask participants to paint a square or rectangle of white paint on the construction paper so that about one or two inches of construction paper is still showing. Let the paint dry and then ask clients to paint a flower, person or a design on the white painted square. When the paint is dry they may outline the design with black marker for an attractive effect.

When the card is completed encourage participants to write a short message or poem to someone they love or have loved in the past.

Discussion/Goals:

Discussion focuses on the design of the card, its symbolism for the artist, and the message inside. Goals include focusing, the expression of feelings, and continuity (being able to follow through on the project).

People in Your Life

Materials:

Magazines, white drawing paper, markers, pen, scissors.

Procedure:

Instruct clients to cut out pictures of people they find appealing and/or who remind them of significant people in their life.

Ask participants to glue the figures on the paper and then write what the figures are thinking and/or saying.[11]

Discussion/Goals:

Discussion focuses on the figures chosen and whom they represent. Goals include exploration of relationships, and expression of thoughts and feelings.

Notes

1. Other printing projects include string printing (dipping string in ink and guiding it across the paper to form a variety of designs), printing with pieces of gauze, using marbles to create prints (rolling marbles in paint and then moving them on the paper) and linoleum and woodcuts (if safe tools are available and if the clientele is highly functional).

2. Thick cardboard can be substituted for wood.

3. From "Scratch board and magic pictures," by D. Oberfest (1976), p.277, in A. Robbins and L.B. Sibley (eds) *Creative Art Therapy.* New York: Brunner/Mazel Publishers.

4. The group can work together on one mobile or each person can create their own.

5. Clients may construct family mobiles to explore further family dynamics, positioning and balance.

6. From "Feeling judgments," by B. Stone (1976), p.231, in A. Robbins and L.B. Sibley (eds) *Creative Art Therapy.* New York: Brunner/Mazel Publishers.

7. Variations include having clients draw their favorite spot for vacations, favorite foods and fruit, etc.

8. See note 2 to Chapter 6 for a recipe for *papier mâché*.

9. This is a variation of a project by Jean Campbell (1993) in *Creative Arts in Group Work*. Oxford, UK: Winslow Press Ltd.

10. From *Creative Arts in Group Work*, by J. Campbell (1993), p.155. Oxford, UK: Winslow Press Ltd.

11. Variations on this project include choosing pictures of individuals that remind you of family members, of people you admire in some way (athletes, scholars, etc.) or of people who look sad, happy, angry, etc.

References

Berensohn, P. (1976) "Pinch pot," in A. Robbins and L.B. Sibley (eds) *Creative Art Therapy*. New York: Brunner/Mazel Publishers.

Buck, J.N. (1978) *The House-Tree-Person Technique*. Los Angeles, CA: Western Psychological Services.

Campbell, J. (1993) *Creative Art in Group Work*. Oxford, UK: Winslow Press Ltd.

Jung, C.G. (1972) *Mandala Symbolism*. New Jersey: Princeton University Press.

Kirson, E. (1976) "Change your dream," in A. Robbins and L.B. Sibley (eds) *Creative Art Therapy*. New York: Brunner/Mazel Publishers.

Landgarten, H. (1981) *Clinical Art Therapy*. NewYork: Brunner/Mazel Publishers.

Machover, K. (1940) *Personality Projection in the Drawing of the Human Figure*. Springfield, IL: Charles C. Thomas Publisher.

Oberfest, D. (1976) "Scratch board and magic pictures," in A. Robbins and L.B. Sibley (eds) *Creative Art Therapy*. New York: Brunner/Mazel Publishers.

Robbins, A. and Sibley, L.B. (1976) "Touch boxes," in A. Robbins and L.B. Sibley (eds) *Creative Art Therapy*. New York: Brunner/Mazel Publishers.

Rosen, M. (1976) "Mural with moveable Cut out figures," in A. Robbins and L.B. Sibley (eds) *Creative Art Therapy*. New York: Brunner/Mazel Publishers.

Rush, K. (1978) "The metaphorical journey: Art therapy in symbolic exploration." *Art Psychotherapy 5*, 149–155.

Stone, B. (1976) "Feeling judgments," in A. Robbins and L.B. Sibley (eds) *Creative Art Therapy*. New York: Brunner/Mazel Publishers.

List of Projects